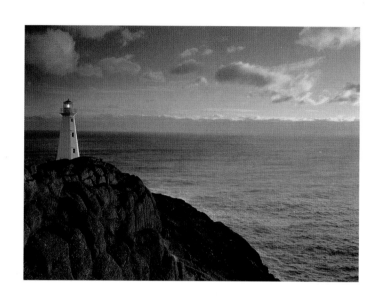

CANADA'S
HISTORIC
SITES

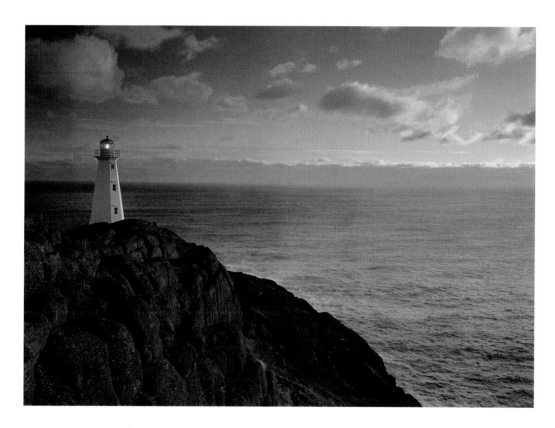

WHITECAP BOOKS
VANCOUVER / TORONTO / NEW YORK

Text by Tanya Lloyd
Edited by Elaine Jones
Photo editing by Tanya Lloyd
Proofread by Lisa Collins
Cover and interior design by Maxine Lea

Printed and bound in Canada

Canadian Cataloguing in Publication Data

Lloyd, Tanya, 1973–

 Canada's historic sites

 ISBN 1-55285-179-6

 1. Historic sites—Canada—Pictorial works. 2. Canada—Pictorial
 works. I. Title.
FC215.L55 2001 971.064'8'0222 C2001-910091-4
F1010.L56 2001

The publisher acknowledges the support of the Canada Council and the Cultural
Services Branch of the Government of British Columbia in making this publication
possible. We acknowledge the financial support of the Government of Canada through
the Book Publishing Industry Development Program for our publishing activities.

For more information on the Canada Series and other Whitecap Books
titles, please visit our web site at www.whitecap.ca.

Many of Canada's historic moments have faded with time, reduced to a few lines in a school textbook or a small plaque by the side of a highway. Driving through the prairie wheat fields, it's easy to forget the nomadic civilizations that once flourished there. Walking amid the bustle of St. John's harbour, it's hard to imagine the astonishment of the first fishing crews to sight this land. What was once a meeting place for First Nations traders is now the metropolis of Winnipeg, and where stagecoaches once plied the streets of Old York, commuters now rush through Toronto.

But scattered across the nation there are a few pockets where history has not been overwritten by the events that followed, where yesterday's homes or battlegrounds have escaped further development. Here, historians and researchers have worked to re-create the past so vividly that it springs to life. A visitor in Louis Riel's childhood home might wonder when the great man is due to return. A sightseer at Cottonwood House in the British Columbia interior might expect the next stagecoach at any moment, bound for the tent cities of the Cariboo Gold Rush. And a wanderer on the grounds of Province House in Charlottetown might not be surprised to meet the fathers of Confederation on the lawns.

In total, there are more than 840 designated national historic sites in Canada, complemented by countless provincial and regional heritage preserves. From those designed to commemorate the growth of human industry, such as Signal Hill in Newfoundland, to places that celebrate ancient peoples, like the village of Ninstints in the Queen Charlotte Islands, each has earned a unique and treasured place in the diverse history of Canada.

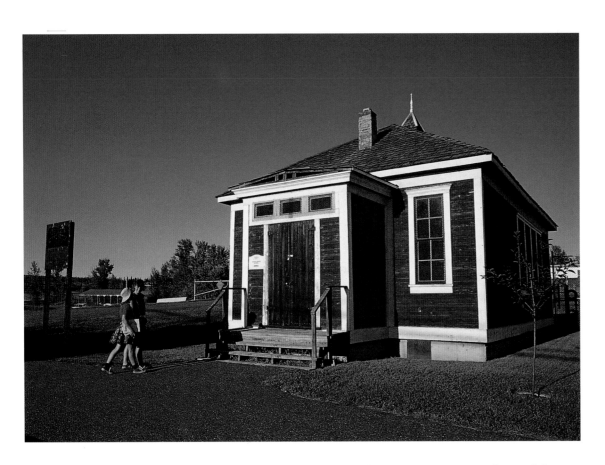

Founded along the Cariboo Wagon Road, the historic route to the gold rush, 150 Mile House in British Columbia was home to one of the region's most famous roadhouses. A small ranching community sprang up around the stopping place.

Barkerville boomed to life after Billy Barker struck gold on Williams Creek. It was soon the largest town in the Canadian west. More than 100,000 people arrived in the Cariboo to seek their fortunes between 1862 and 1870.

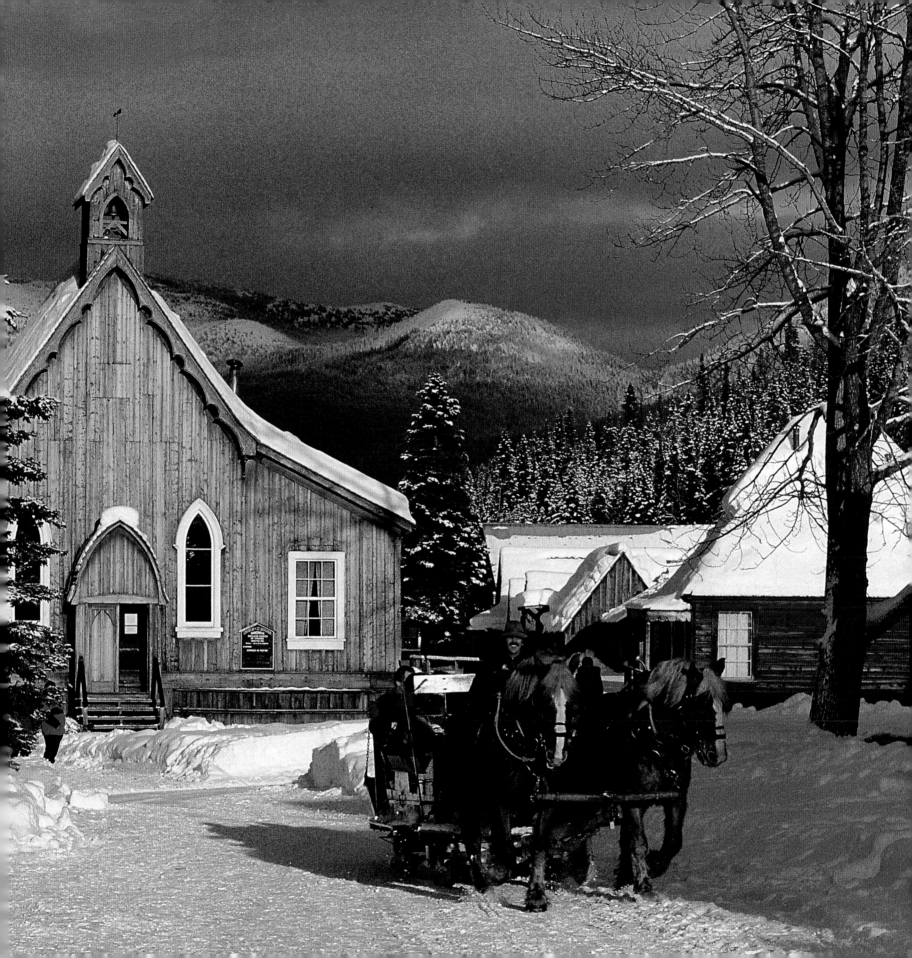

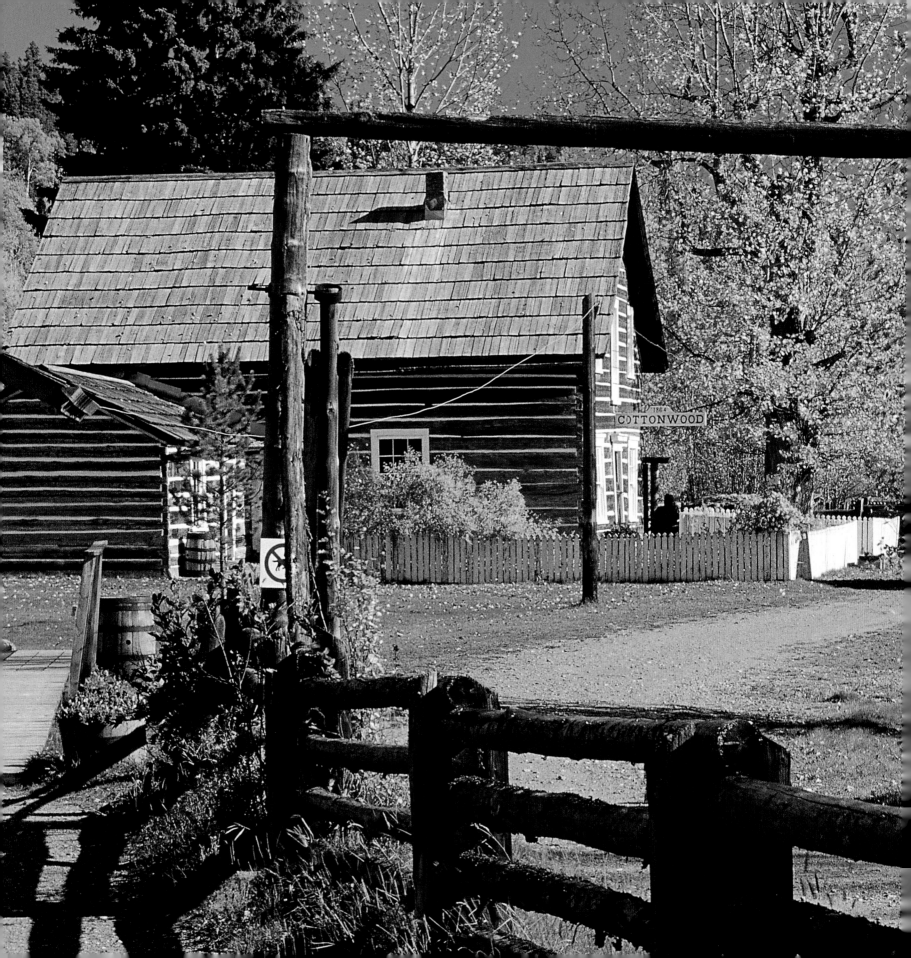

Built between 1864 and 1865, Cottonwood House served as an oasis of comfort on the road to the Cariboo Gold Rush, offering meals and accommodations and a place for the stagecoaches of the day to change horses.

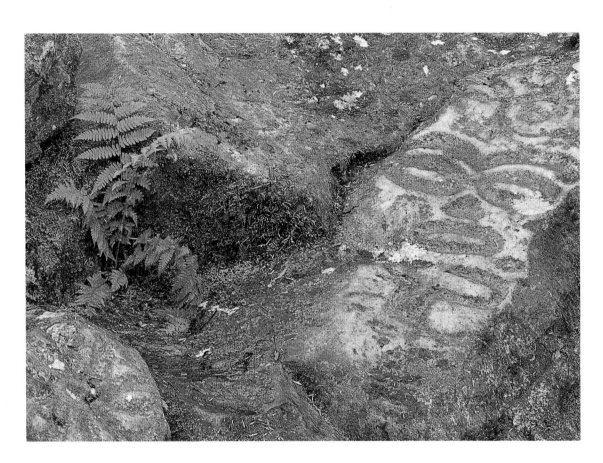

Petroglyphs, or ancient rock carvings, bear witness to the people who travelled B.C.'s coast centuries ago. There are more than 500 rock carvings and paintings in the province—more than in any other part of Canada.

Declared a UNESCO World Heritage Site in 1981, the village of Ninstints and its famous Haida mortuary poles are more than a century old. Protected by Gwaii Haanas National Park, they offer an intriguing look at the history of the First Nations people along the Pacific coast.

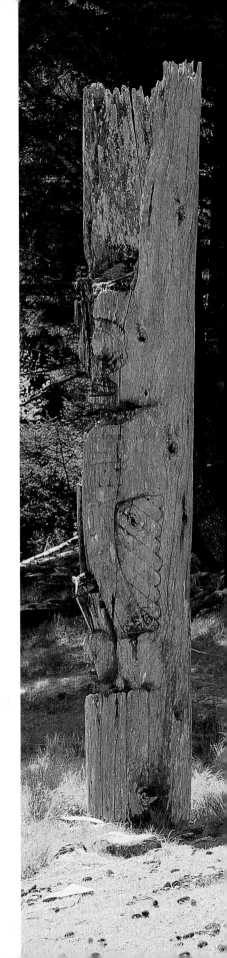

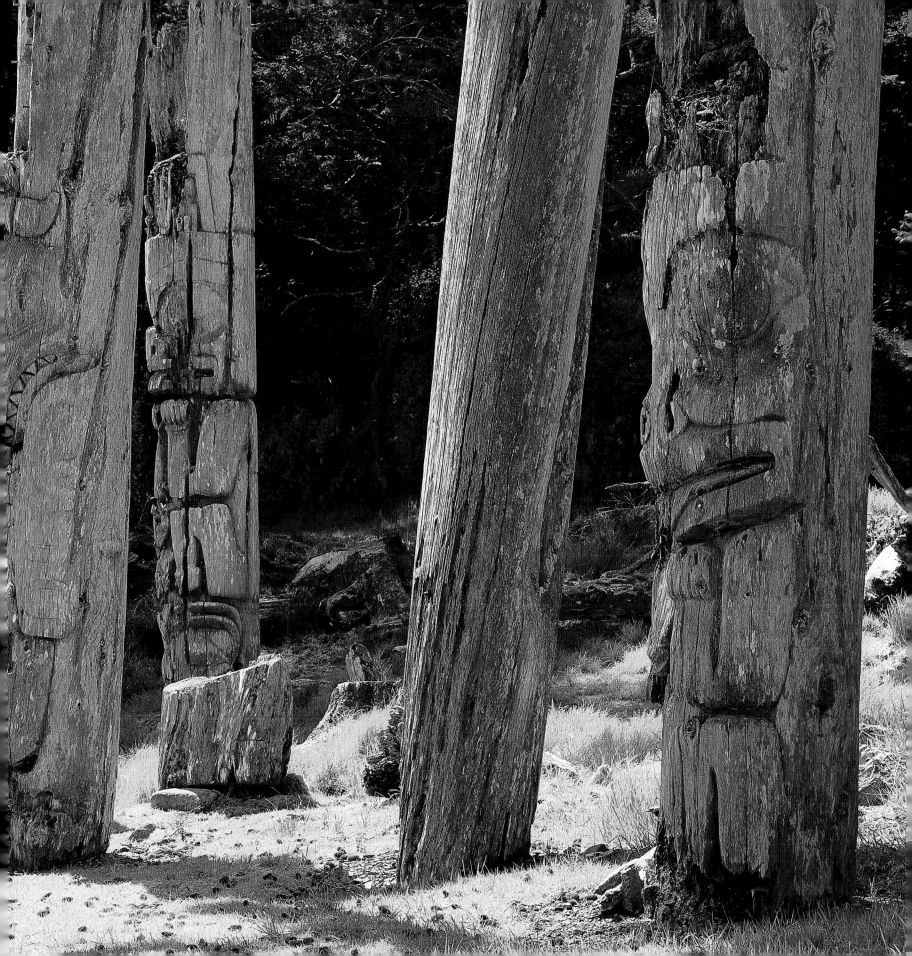

Hatley Castle was commissioned by Lieutenant-Governor Dunsmuir for a family estate and was completed in 1908. It later served as part of Royal Roads Military College before becoming the administrative centre for Royal Roads University near Victoria, BC.

FACING PAGE—
When it was built by the British in 1860, Fisgard Lighthouse was the first permanent lighthouse on what was later to become Canada's west coast. Though it was automated in 1929, the beacon still operates, signalling the entrance to Esquimalt's harbour.

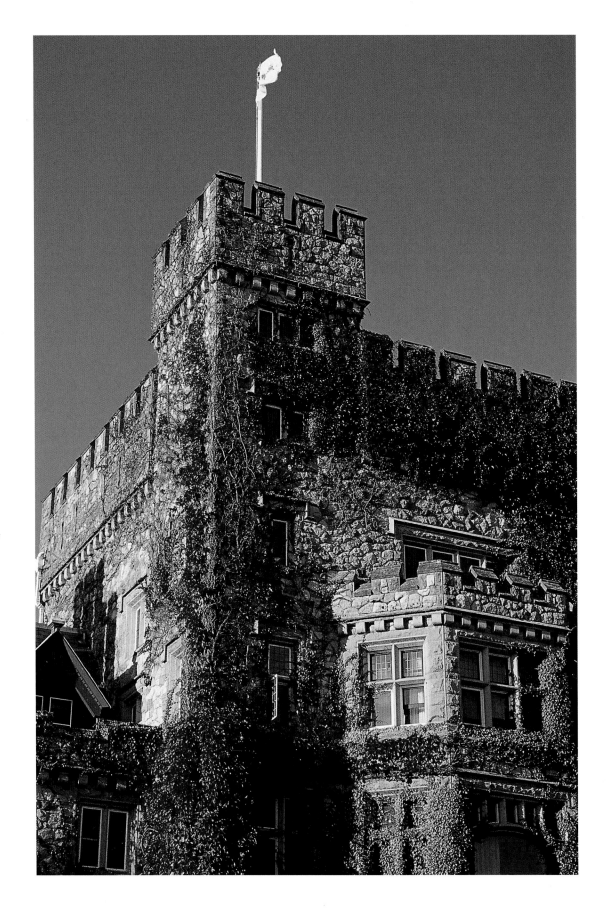

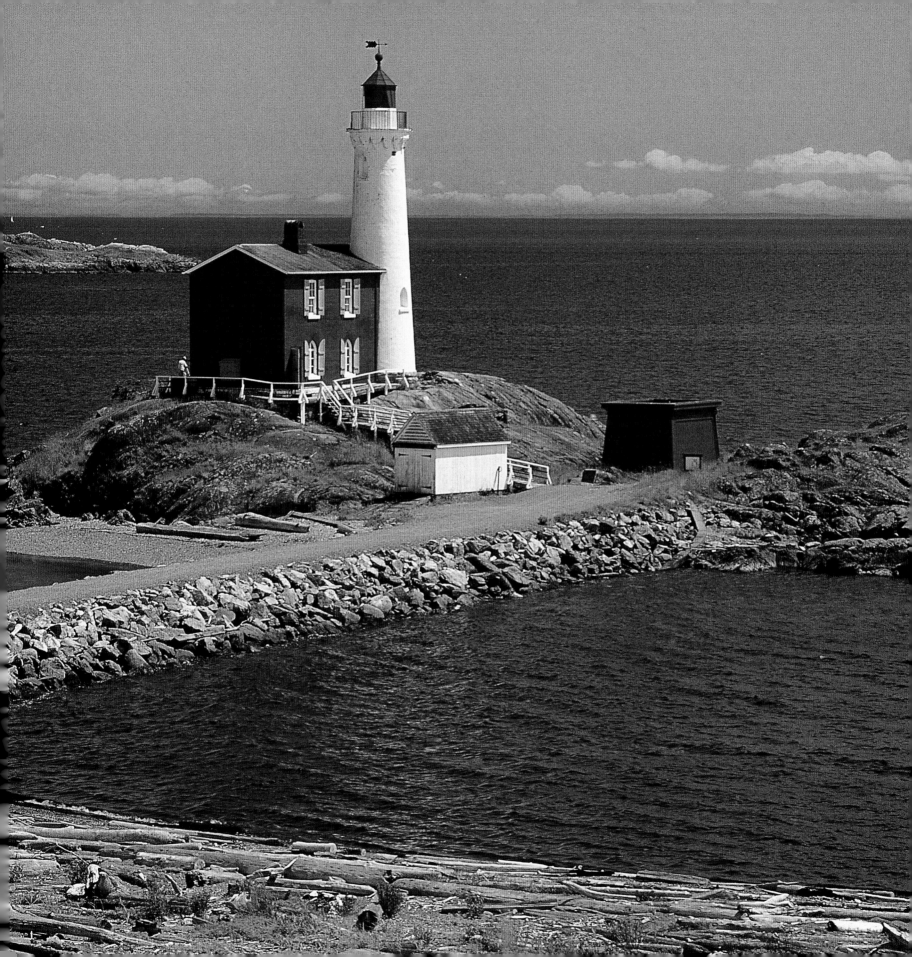

Inside the Gulf of Georgia Cannery National Historic Site, visitors wander through displays of about 10,000 artifacts, all relating to British Columbia's salmon, herring, and halibut fisheries. The cannery was built in 1894, grew to become the province's largest producer of canned salmon, and operated until 1947.

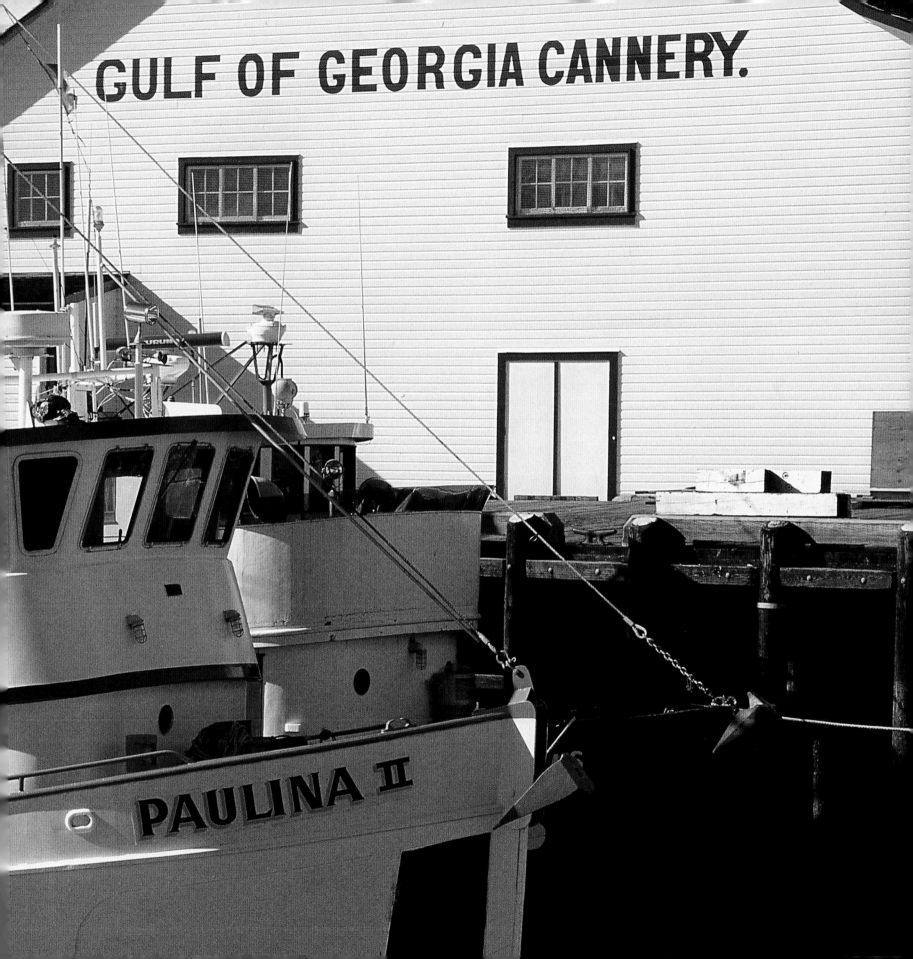

Vancouver's oldest district, Gastown, bears the name of "Gassy" Jack Deighton, a talkative riverboat captain who opened the city's first saloon here in the late 1800s.

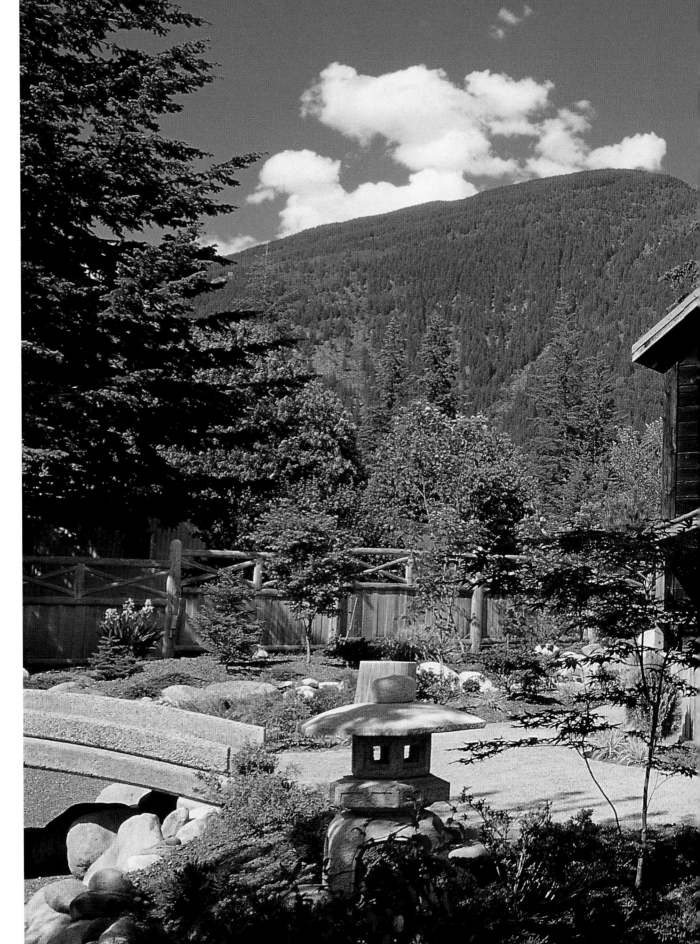

During World War II, about 21,000 people of Japanese descent were stripped of their property and sent to internment camps in Canada's interior. In New Denver, British Columbia, the Nikkei Internment Memorial Centre commemorates their struggles.

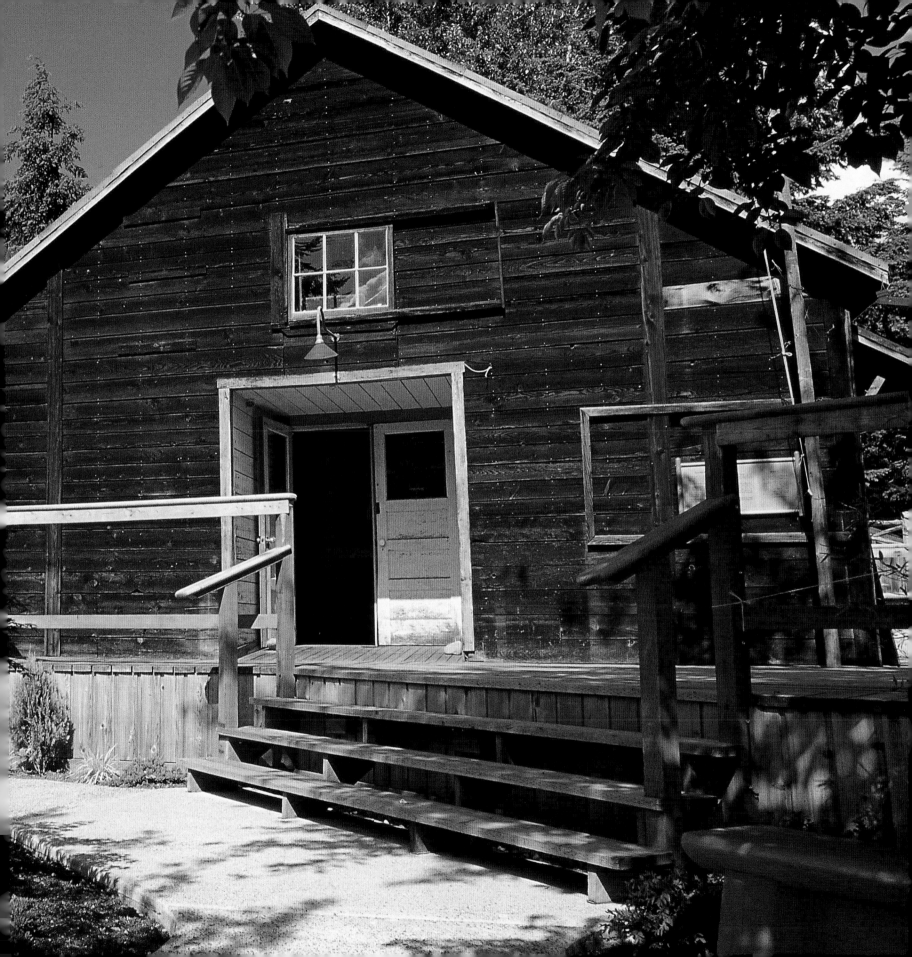

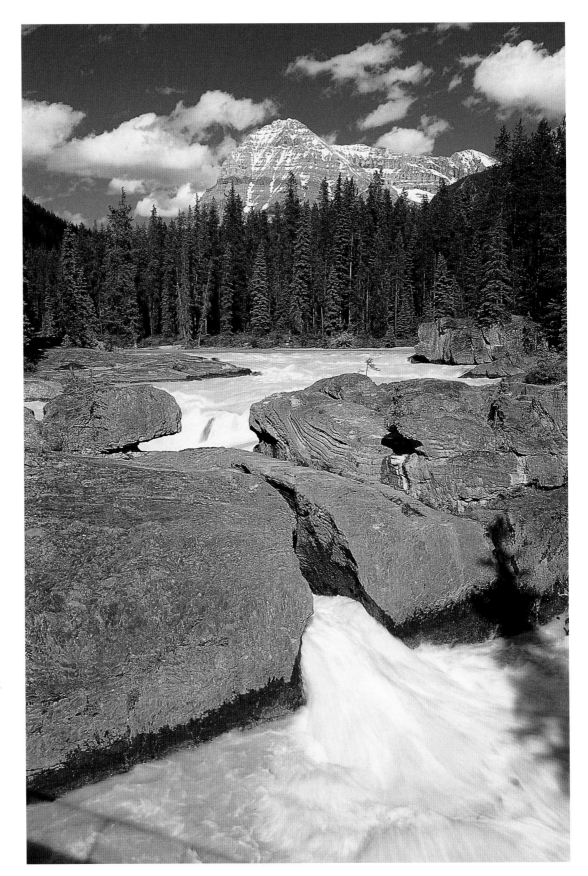

Explorer James Hector was the first European to chart the Kicking Horse Pass in the Rocky Mountains in 1858. In the early 1900s, the pass became the highest point on the Canadian Pacific Railway, which reached 1,627 metres (5,338 feet) after spiralling through two major tunnels.

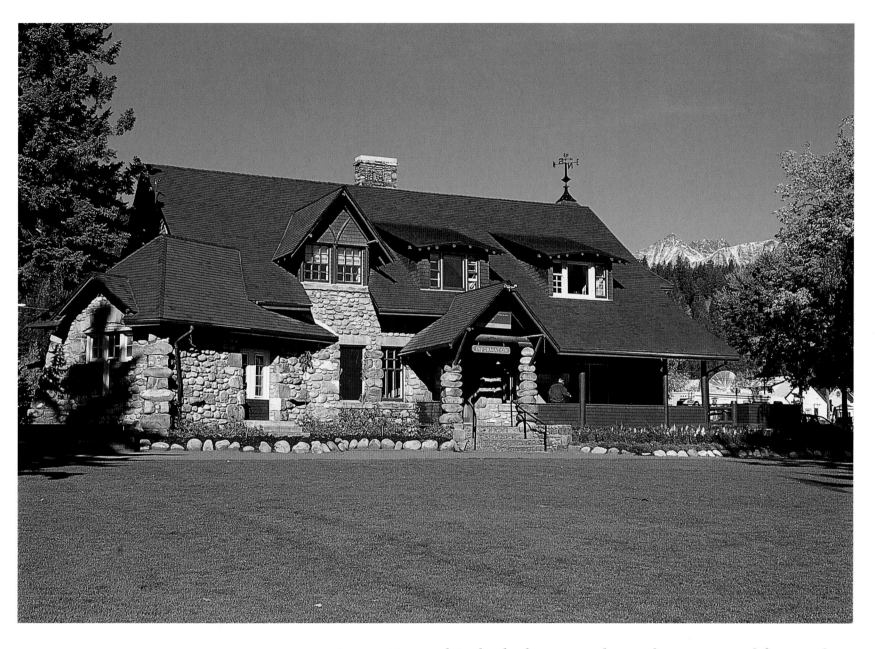

Jasper National Park, the largest in the Rockies, is named for North West Company trader Jasper Hawes, who lived here in the early 1800s. Almost a century later, in 1907, the Canadian government declared this a national preserve.

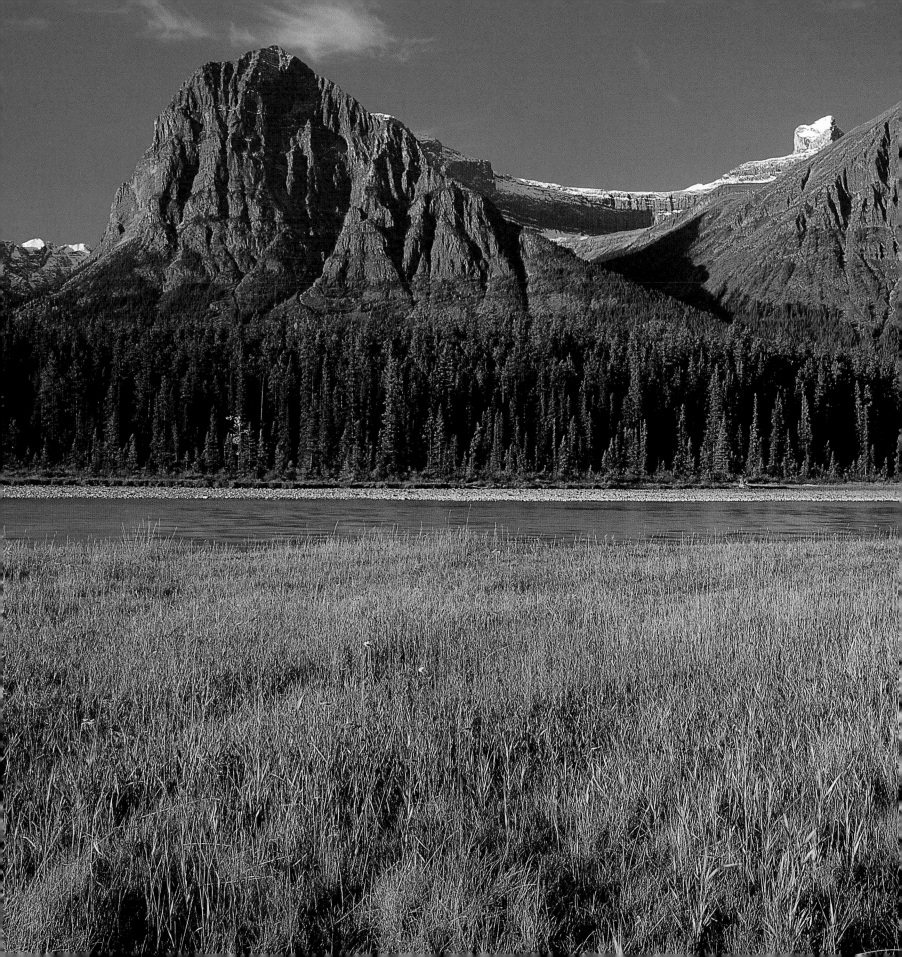

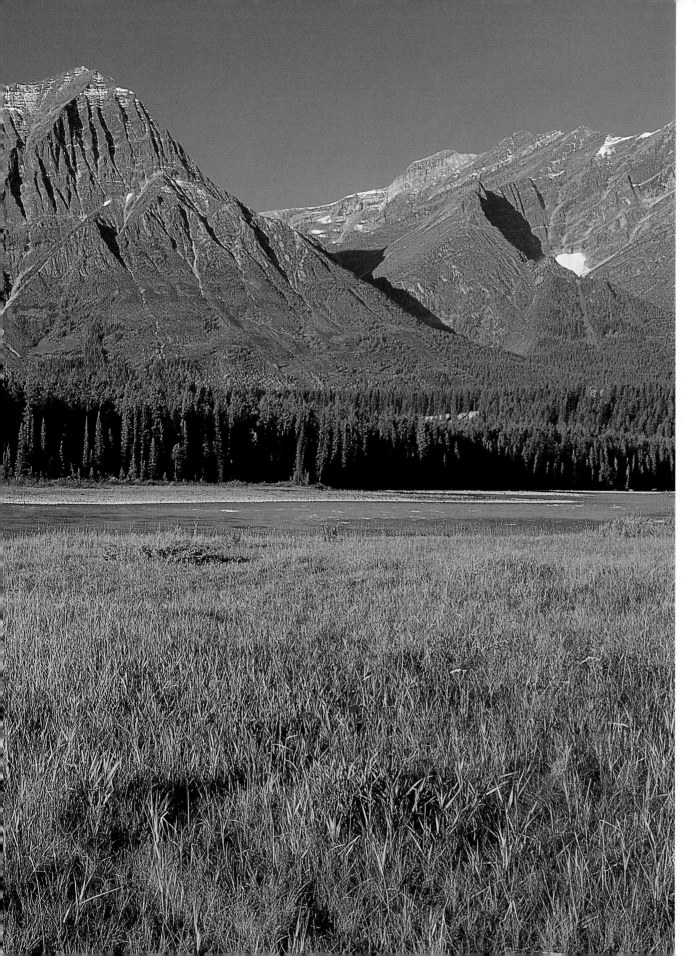

Explorer David Thompson made his way through Athabasca Pass in 1810, led by native guides to the shores of the Columbia River, where he spent the winter. He reached the Pacific in July, 1811.

23

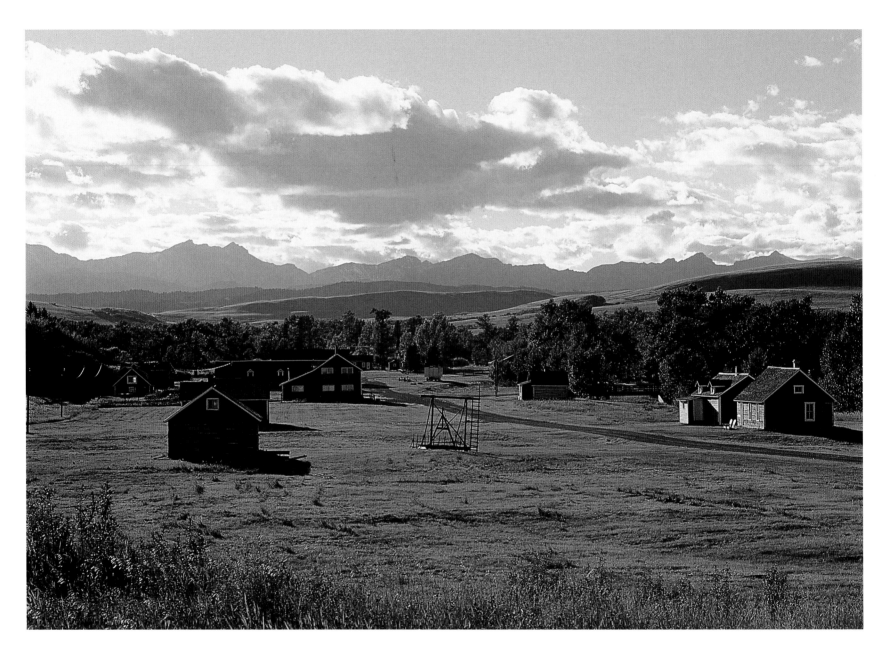

Alberta's Bar U Ranch was founded in the late 1800s and gained renown as one of the world's best-run cattle ranches. Also known for its top show horses, the ranch remained in operation throughout the Depression, finally closing in 1950. The Canadian government declared a portion of the ranch a National Historic Site in 1995.

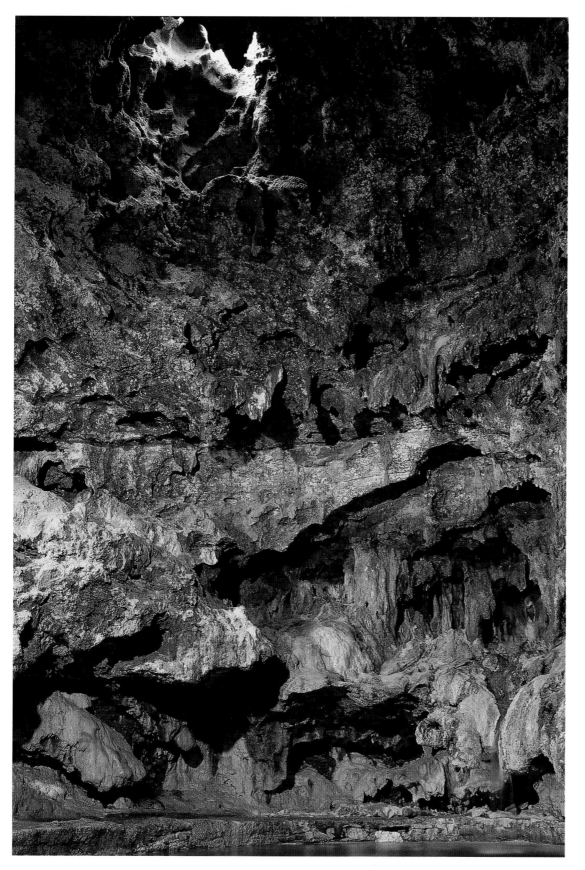

In 1883, workers on the Canadian Pacific Railway stumbled upon a steam-filled limestone cave. One of them, William McCardell, called it "some fantastic dream from a tale of the Arabian nights." After several conflicting claims were staked on the site, the government purchased the land and set it aside as part of what would become Banff National Park.

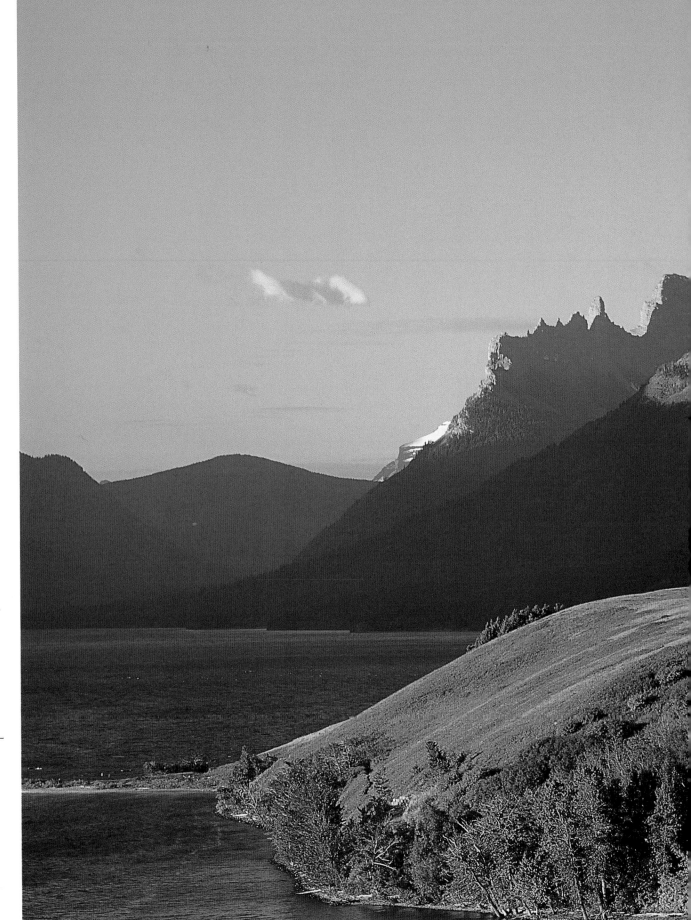

Overlooking Waterton Lake, the 87-room Prince of Wales Hotel was completed in 1927 by an American railway company. The hotel is now within Waterton/Glacier International Peace Park, which spans the Alberta-Montana border.

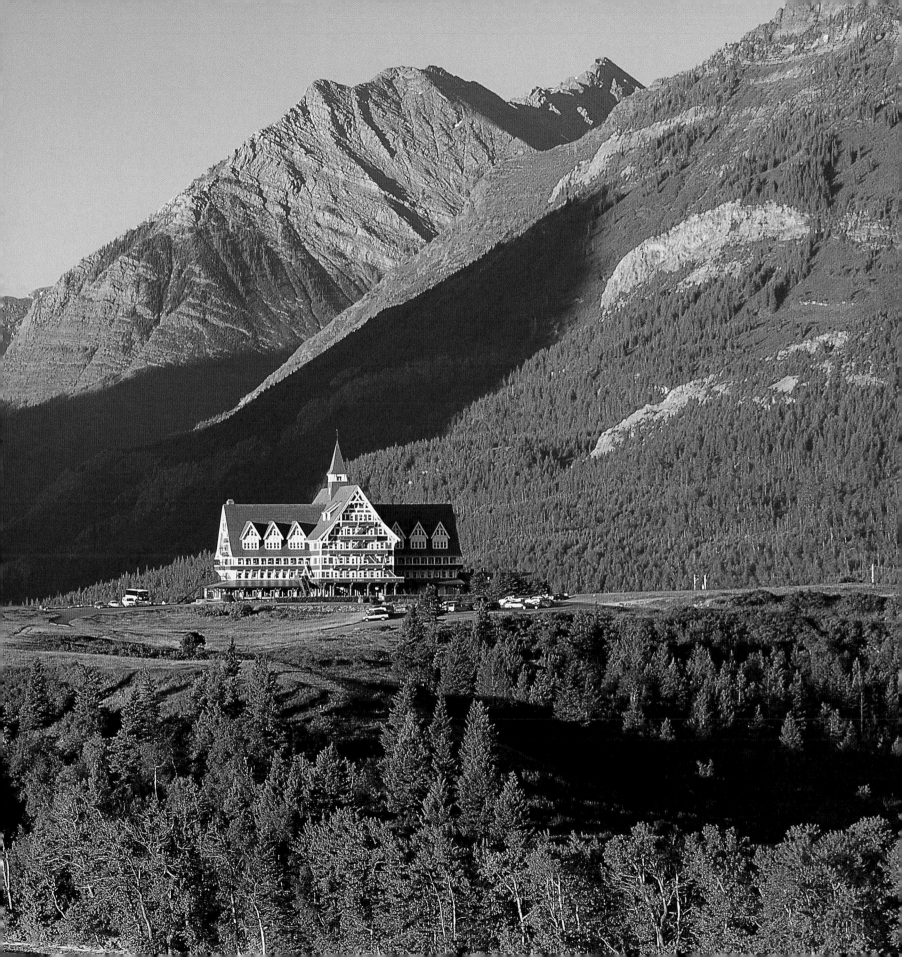

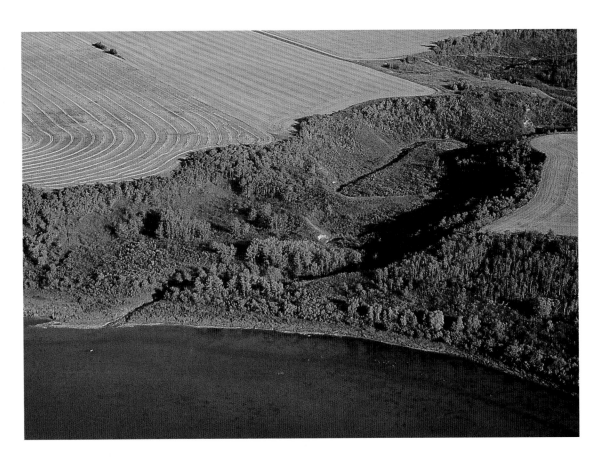

The site of one of the five major battles in the 1885 North-West Rebellion, Fish Creek is now a picturesque preserve along the South Saskatchewan River.

Fort Edmonton traces the region's history from the fur trade era through the arrival of the railroad to the present day. Restored buildings, including a blacksmith's shop, a watchtower, a chapel, and a general store, allow visitors to experience the past.

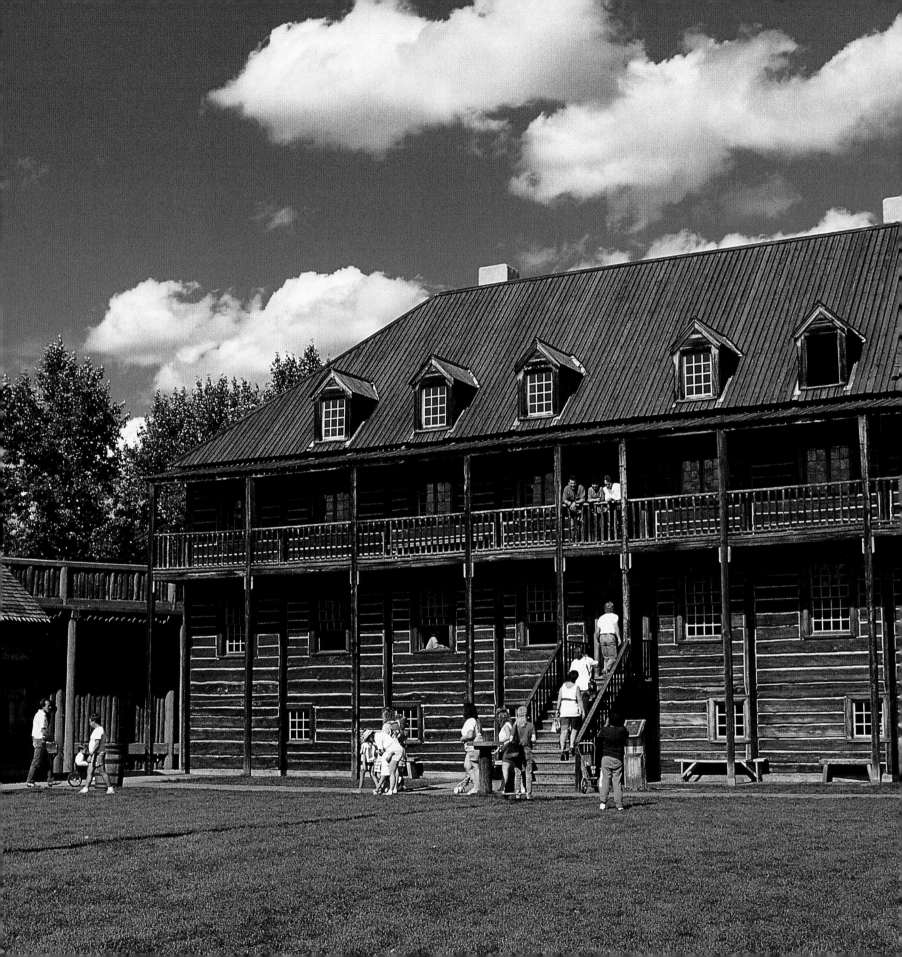

A national historic site welcomes visitors to Batoche. Louis Riel created a headquarters and declared a provincial government in this village, leading the Métis people into the last battle of the 1885 North-West Rebellion. In part, the Métis were fighting against the usurping of their land by the Canadian government and increasing numbers of white settlers.

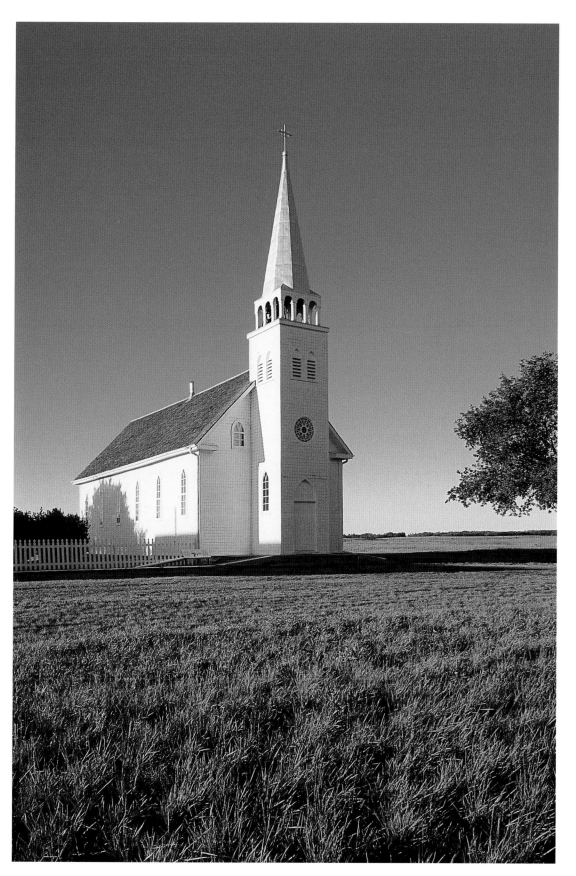

The mission, church, and rectory in Batoche have been restored and now appear as they would have in the late nineteenth century. The rectory still bears the scars of that time— bullet holes remind visitors of warning shots fired on the first day of the battle.

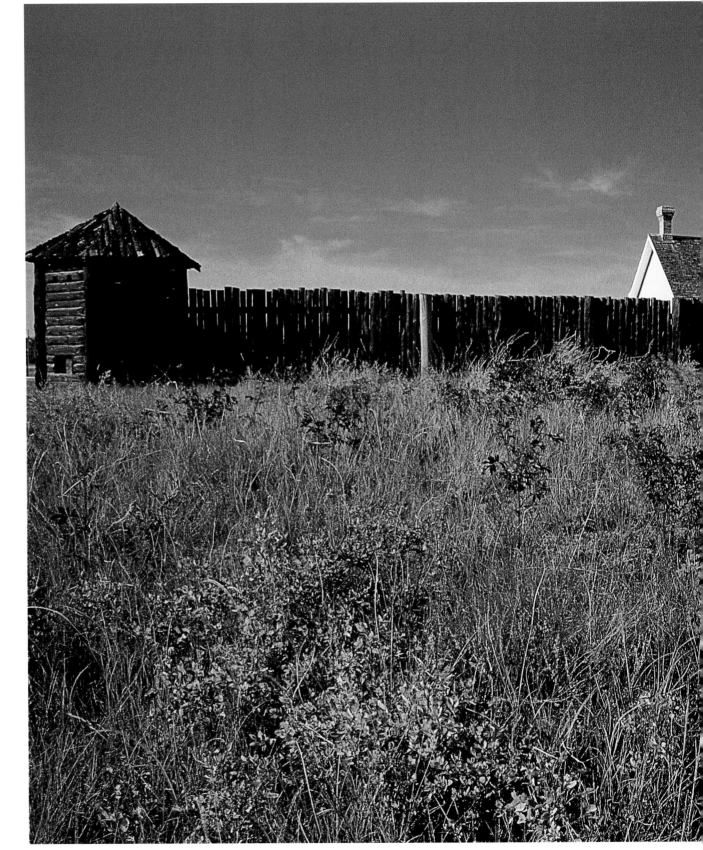

When the North-West Mounted Police founded Fort Battleford in 1876, the outpost was named the capital of Canada's new North-West Territories. Although the capital was soon moved to Regina, officers at Fort Battleford continued to supervise the settlement and trade of the west.

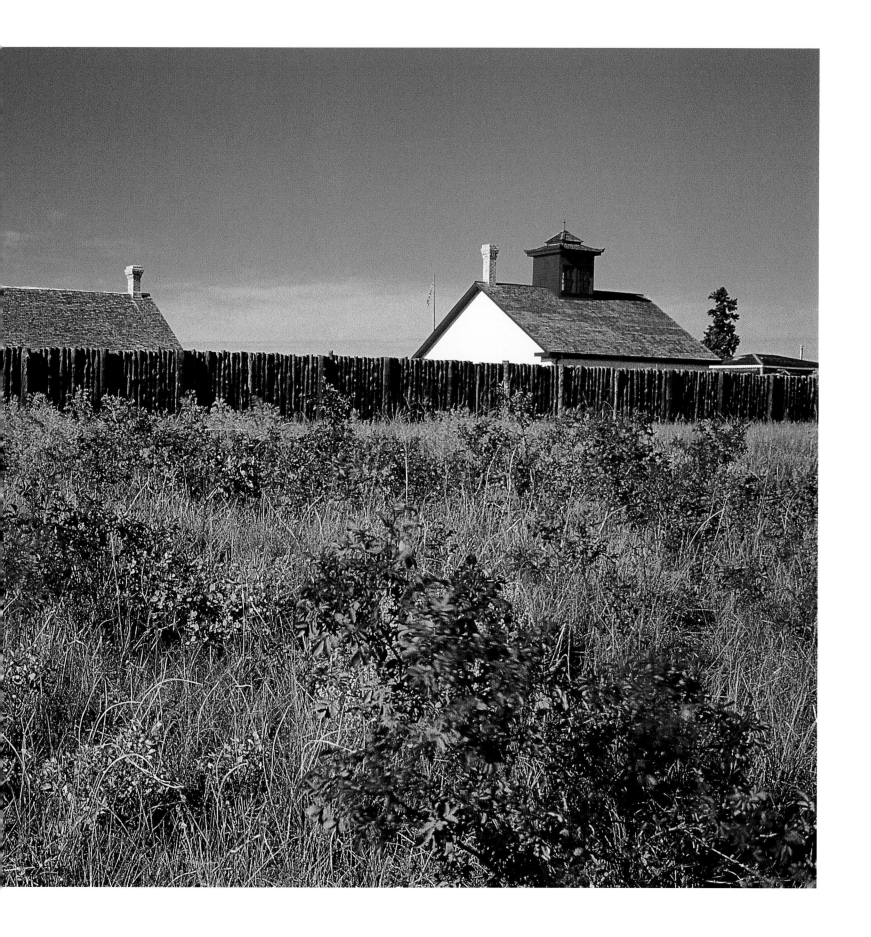

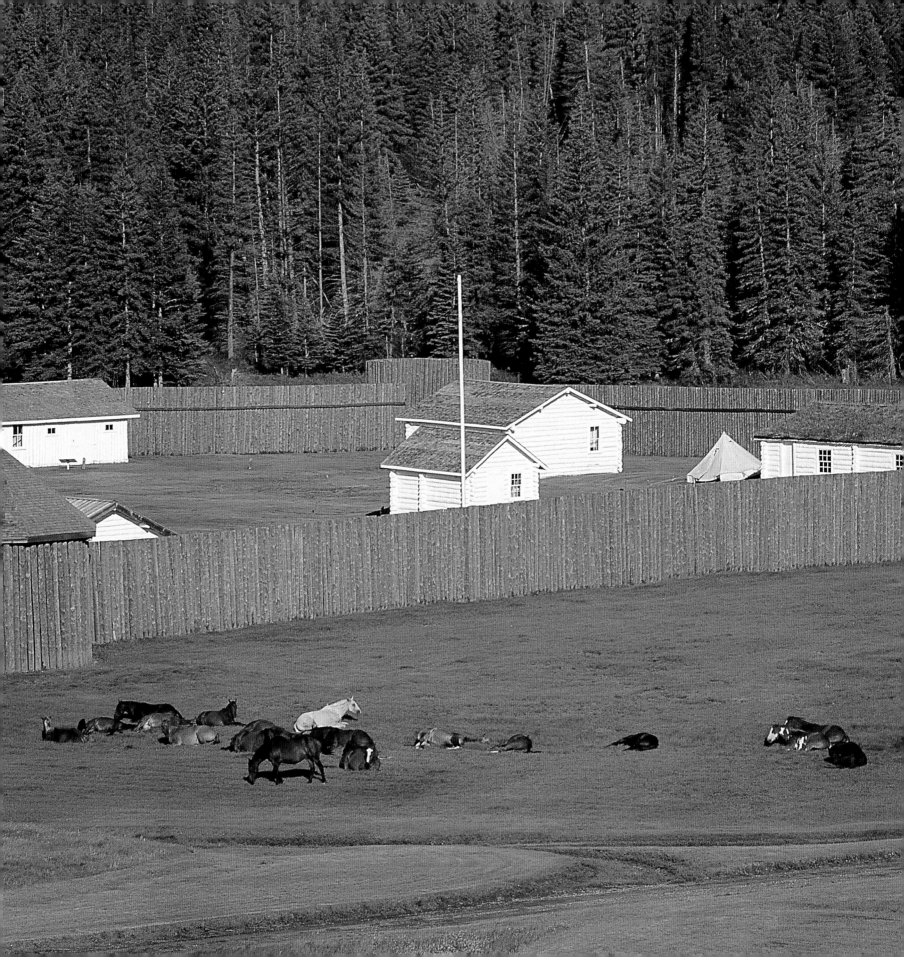

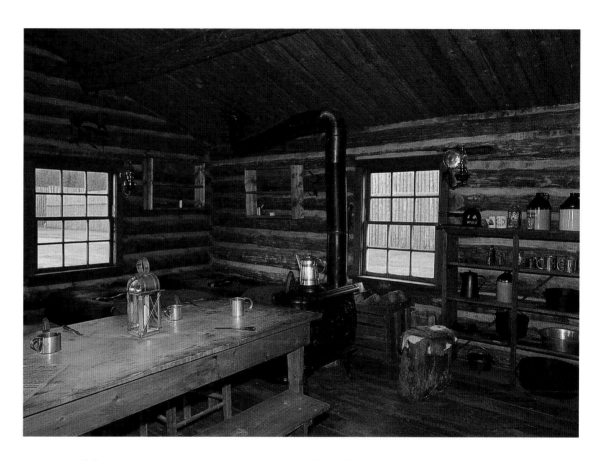

Fort Walsh National Historic Site in Saskatchewan welcomes visitors to Canada's wild west, where American traders once offered whiskey in exchange for furs at Farwell's Trading Post.

After wolf hunters and whiskey traders slaughtered First Nations families in the Cypress Hills Massacre of 1873, the North-West Mounted Police were sent west to establish Fort Walsh and bring order to the Canadian west.

The Viking statue in
Gimli pays tribute
to the heritage of
Icelandic Canadians.
Driven from Iceland
by economic hard-
ship, they established
the Republic of New
Iceland on the shores
of Lake Winnipeg.
The town remains
the largest Icelandic
community outside
of Iceland.

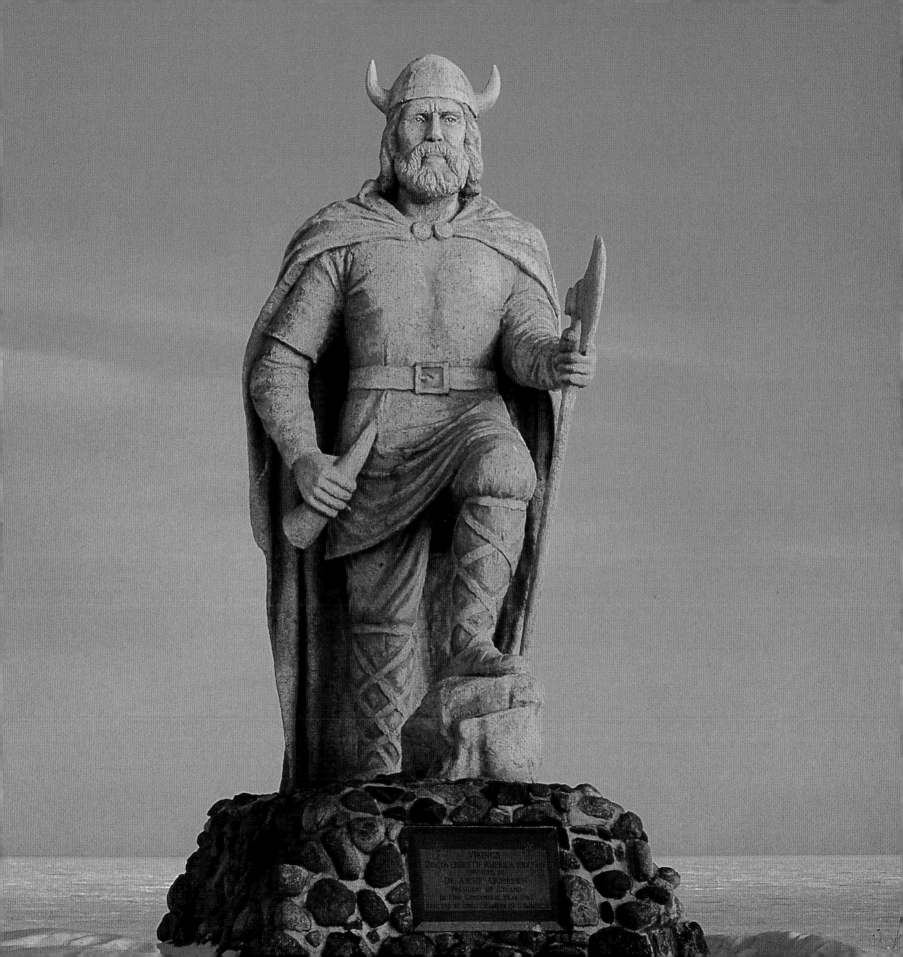

VIKINGS
DISCOVERERS OF AMERICA 1000 A.D.
PRESENTED BY
DR. ACLI ASMUNDSON
PRESIDENT OF ICELAND
IN THE CENTENNIAL YEAR 1967
ERECTED BY THE CHAMBER OF COMMERCE

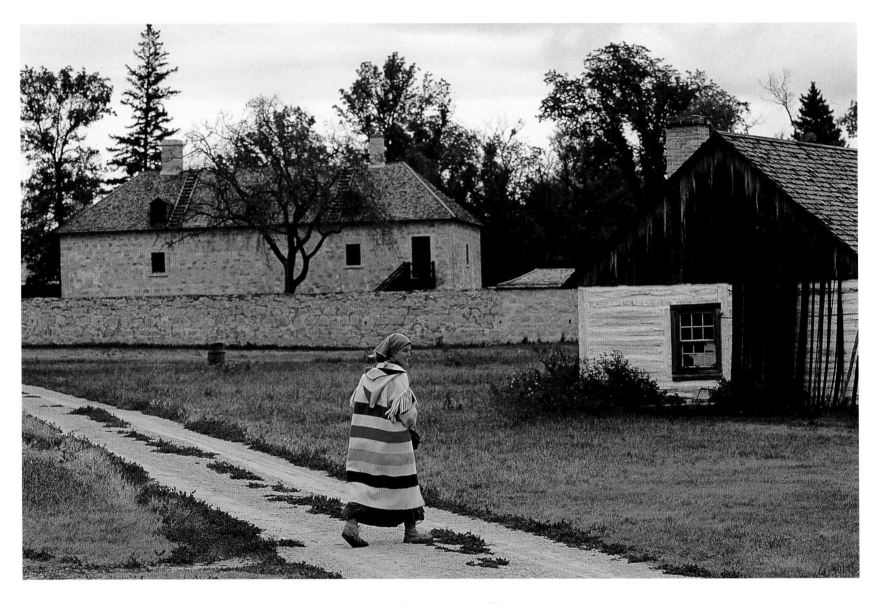

Manitoba's Lower Fort Garry is the oldest stone trading post still intact in North America. Building began in 1831, and the fort served as a commercial hub for the Hudson's Bay Company for decades.

Before the construction of Lower Fort Garry, much of the food for the Hudson's Bay Company's outposts came from Europe. By purchasing surplus from the farms of the Red River Valley, the company was able to send food overland to its posts, drastically cutting costs.

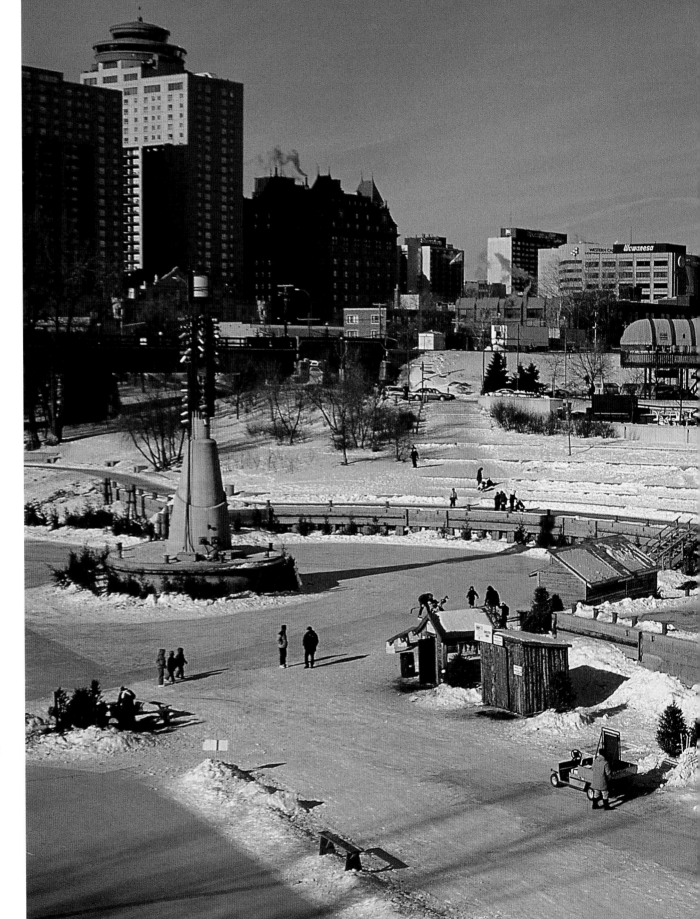

Many of the buildings now preserved at the historic Forks area of Winnipeg date from the time of the railways. Union Station, in the centre of the photo, was completed in 1911 and was designed by Warren and Wetmore Architects, the firm that created Grand Central Station in New York.

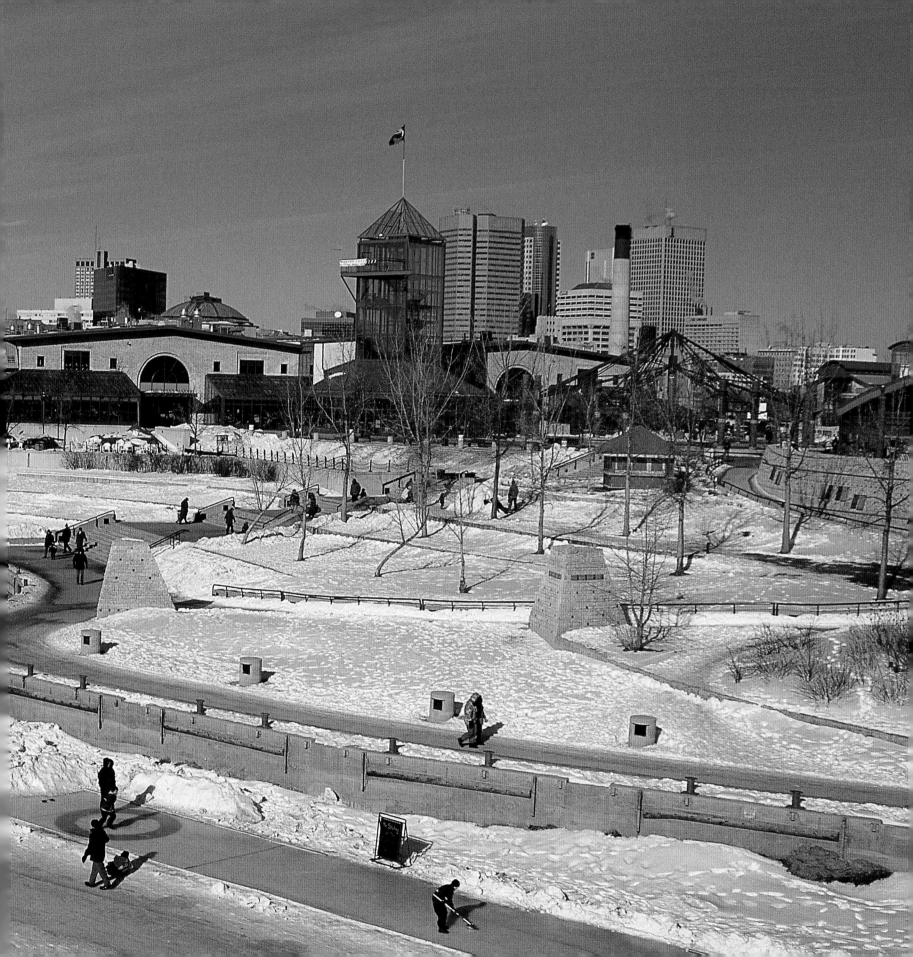

When Louis Riel was hanged in 1885, his body lay in state in his mother's house in Winnipeg for two days. His descendants continued to live there until 1969.

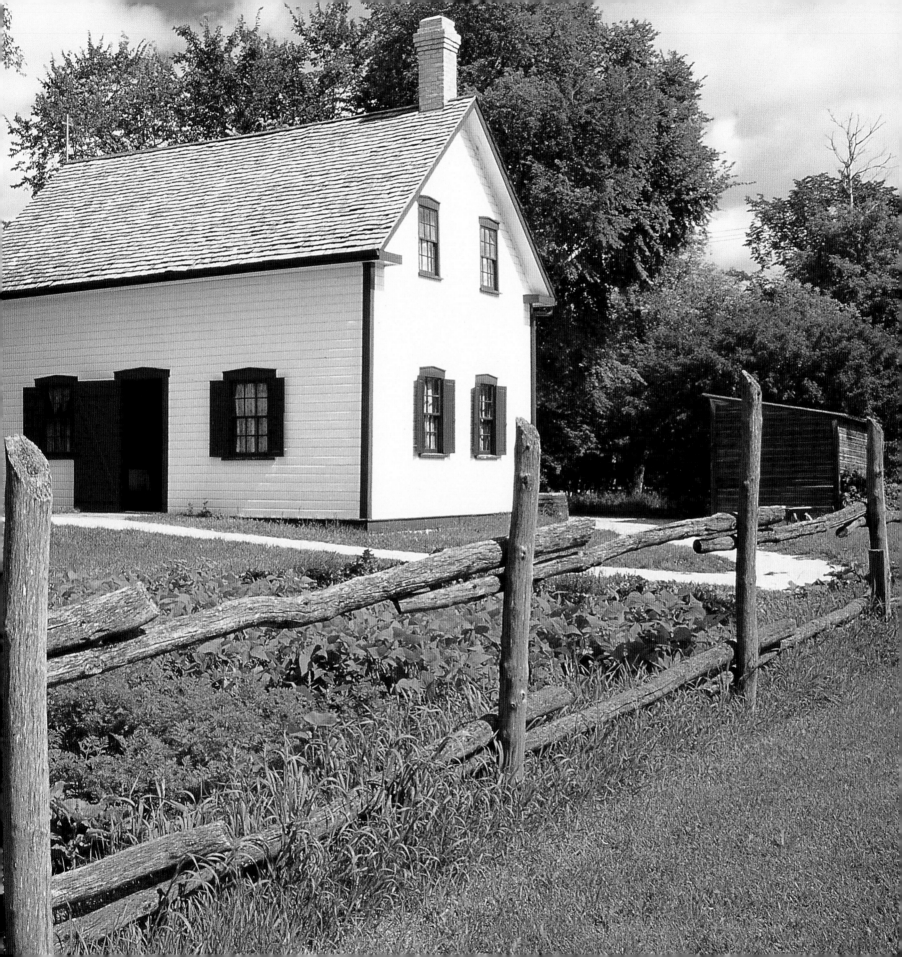

Archaeologists in Manitoba's Riding Mountain National Park have found evidence of human habitation spanning more than 6,000 years. Today, interpretive sites within the preserve explore the native traditions of fishing, hunting, tool making, burial, and more.

FACING PAGE—
Thousands of grain elevators once dotted the prairies, but many fell into disrepair with the closure of minor rail lines. The community of Inglis has banded together to preserve the five local elevators, creating a heritage site to commemorate the rich history of settlement and farming in Manitoba.

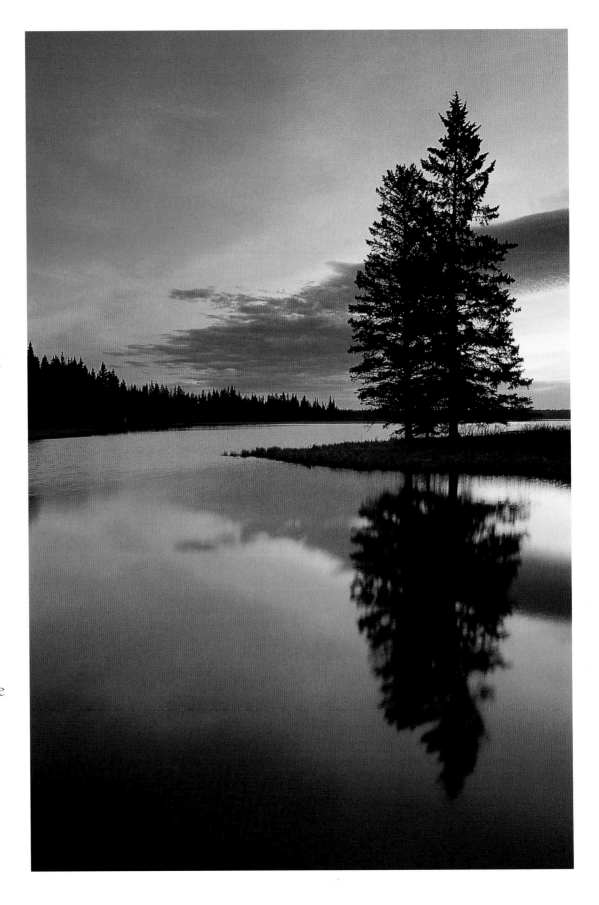

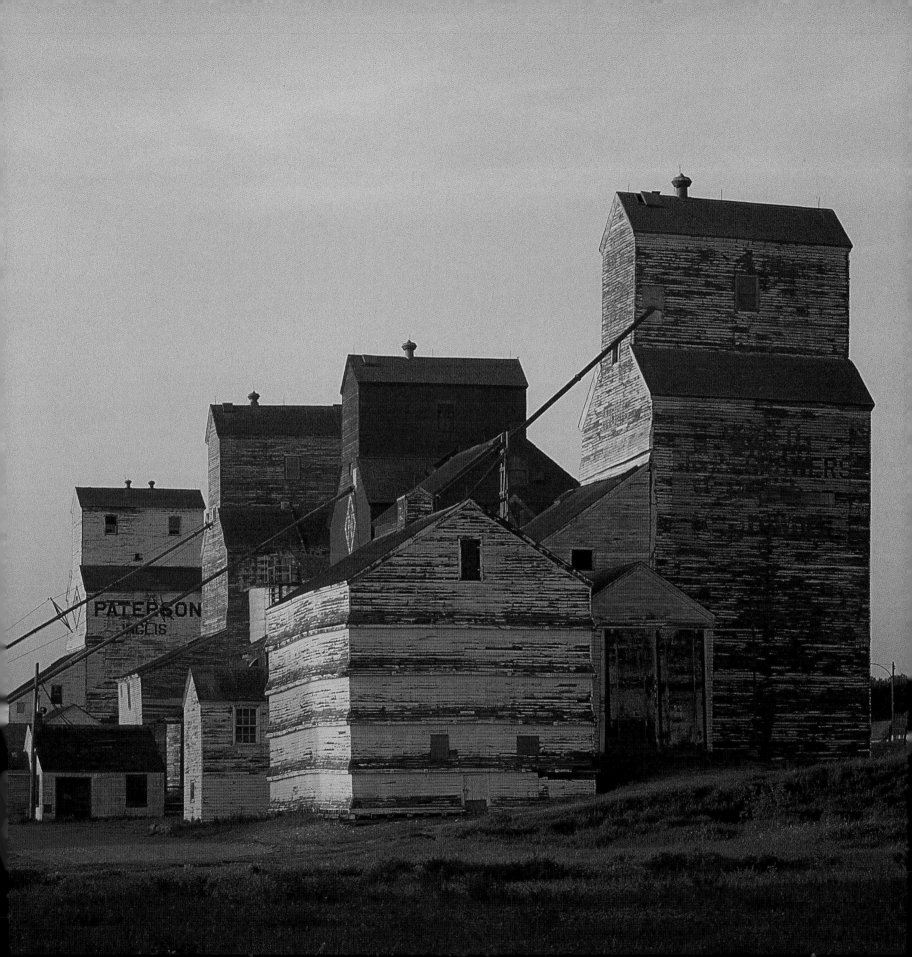

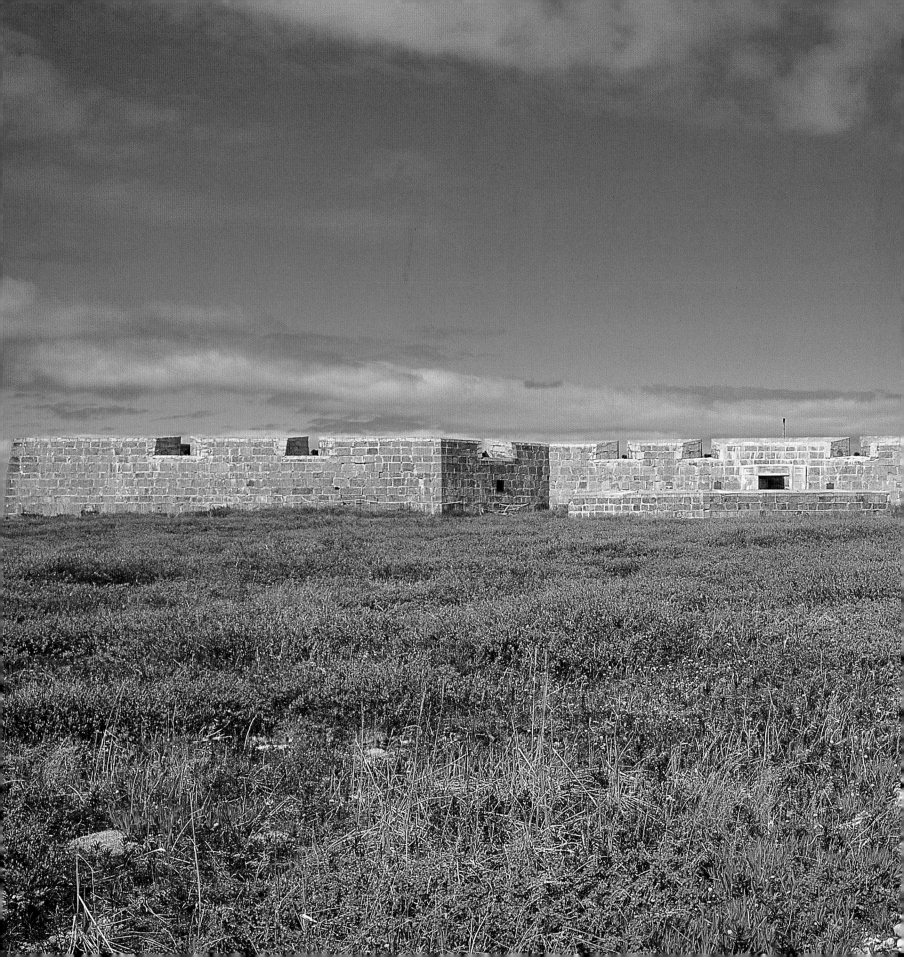

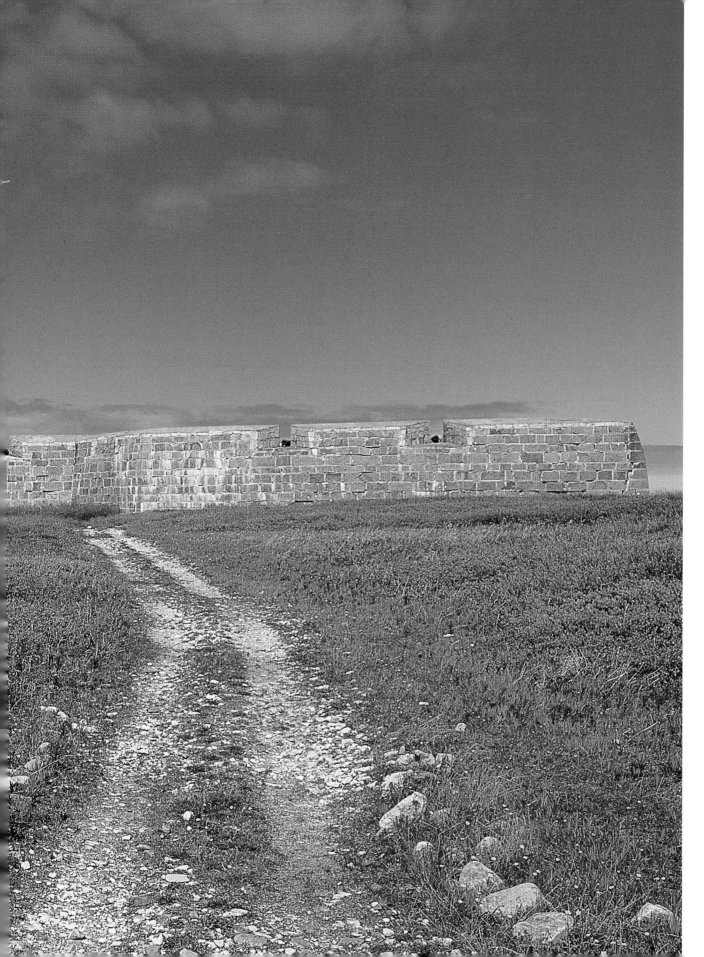

The British out-
posts built on the
Churchill River in
the eighteenth cen-
tury were intended
to increase trade in
the northern reaches
of Rupert's Land and
protect the compa-
ny's ships in the
event of war.

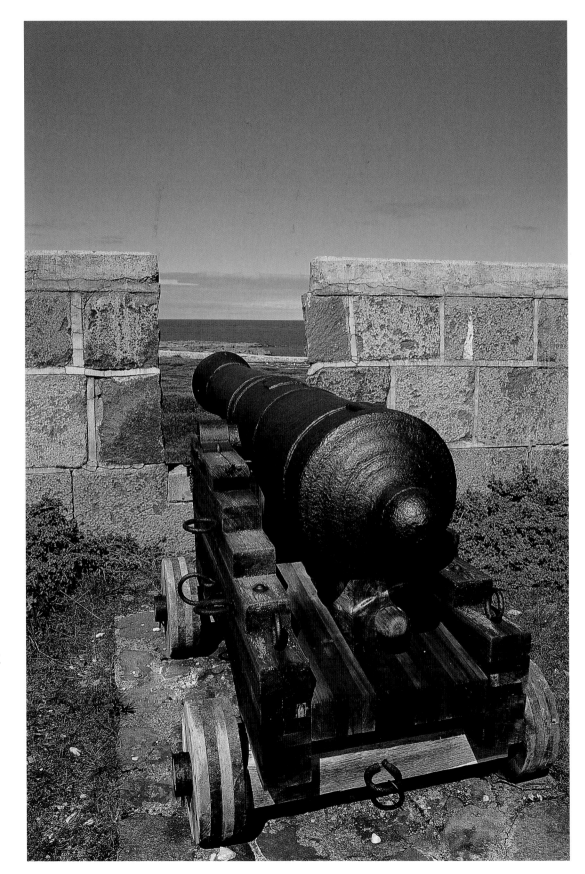

The massive stone walls—
11 metres (36 feet) thick—
of Fort Prince of Wales in
northern Manitoba are built
of quartzite and limestone
quarried nearby. It took 24
tradespeople and 80
labourers more than
40 years to complete
the structure.

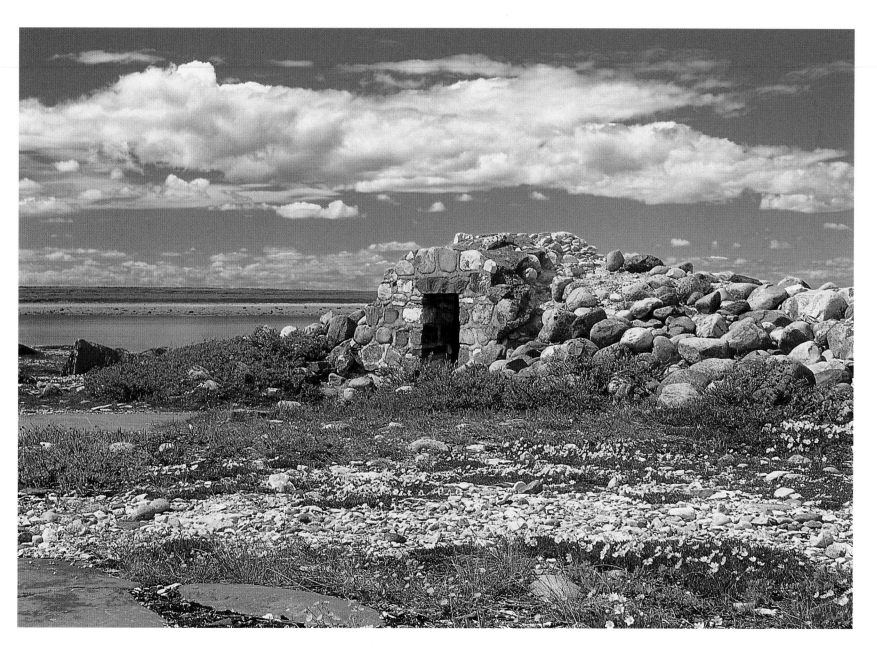

The men who built the fortifications at Prince of Wales and Cape Merry faced conditions they had never imagined. Temperatures dropped dramatically in winter; even in August, a blizzard could suddenly descend.

An inukshuk overlooks the barren shores of Hudson Bay. Hudson's Bay Company employee James Knight first saw Cape Merry in 1717, naming this outcropping Knight's Round Point. It was renamed in honour of Captain John Merry, deputy governor of the Hudson's Bay Company from 1712–1718.

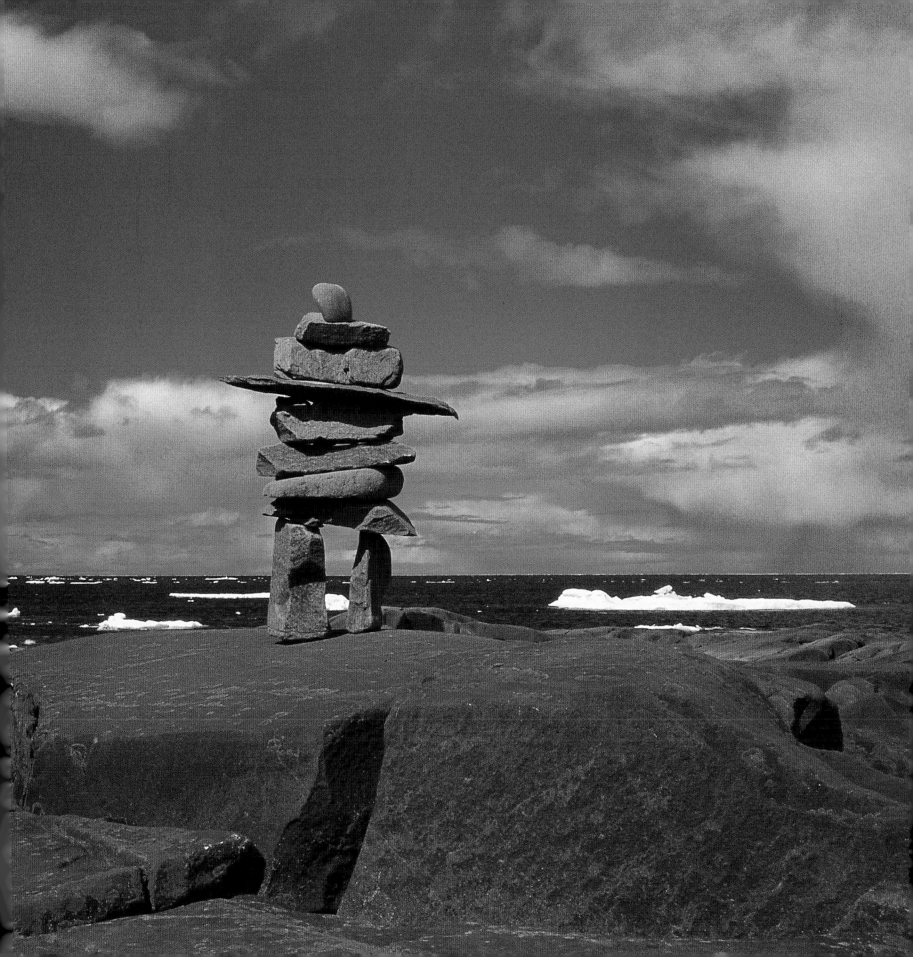

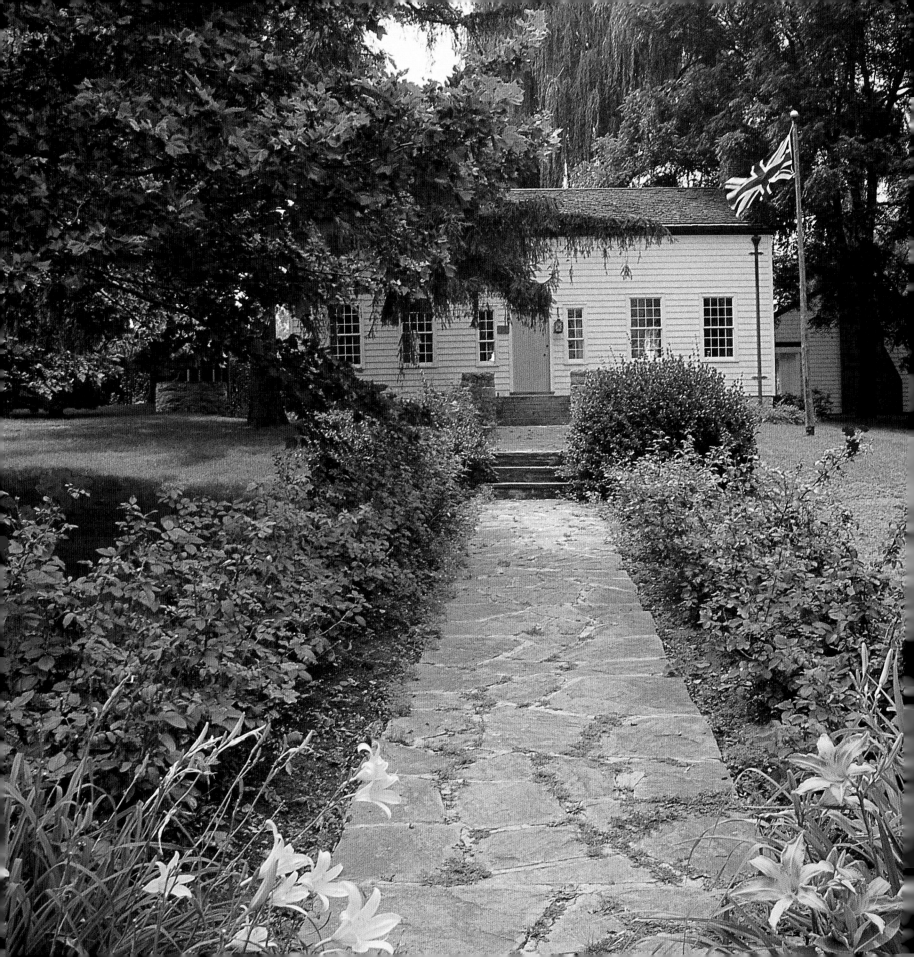

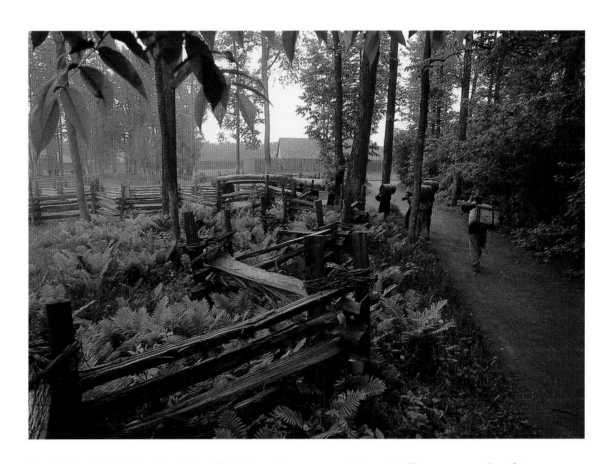

Built in 1803 by the North-West Company, Fort William was the first European settlement at present-day Thunder Bay. Here, traders reenact the summers when thousands of voyageurs from the interior arrived here to meet with fur traders from the east.

Laura Secord was billeting American soldiers in her home in June, 1813, when she overheard their plans to attack at Beaver Dams. Alone, she walked 32 kilometres (20 miles) to warn the British forces.

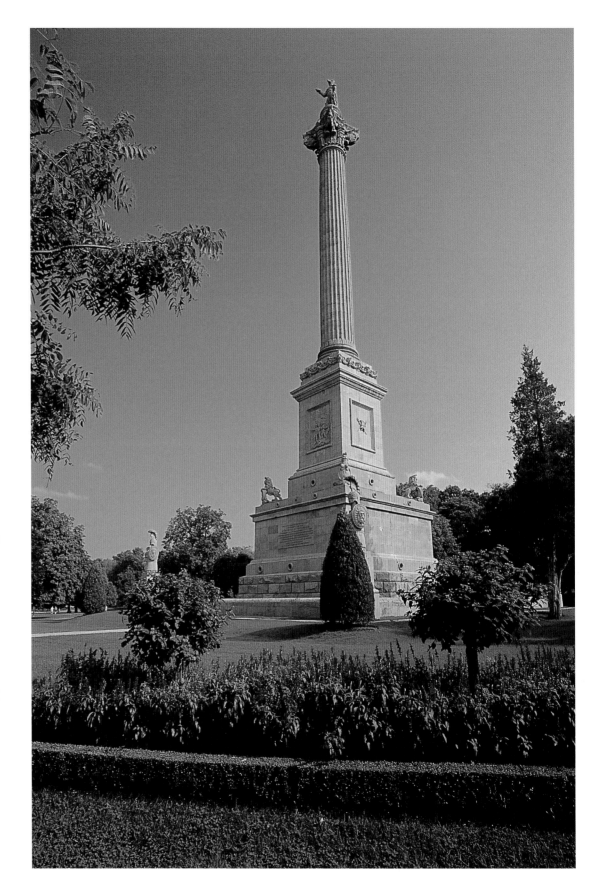

The first monument at this site was built in 1824 to commemorate the acts of General Isaac Brock, who fought and died in Queenston, Ontario, during the War of 1812. A bomb set by a sympathizer with the Mackenzie Rebellion destroyed the tower in 1838. The present monument was created 15 years later.

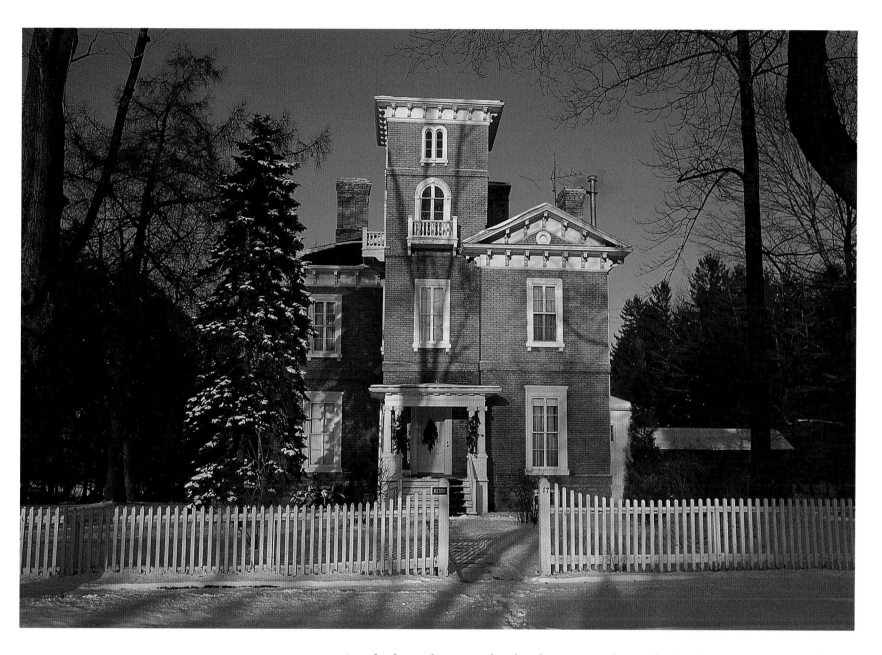

On dark nights, guides lead visitors through the historic streets of Niagara-on-the-Lake, Ontario, by candlelight, pointing out "haunted" places and telling tales of ghostly encounters in the town.

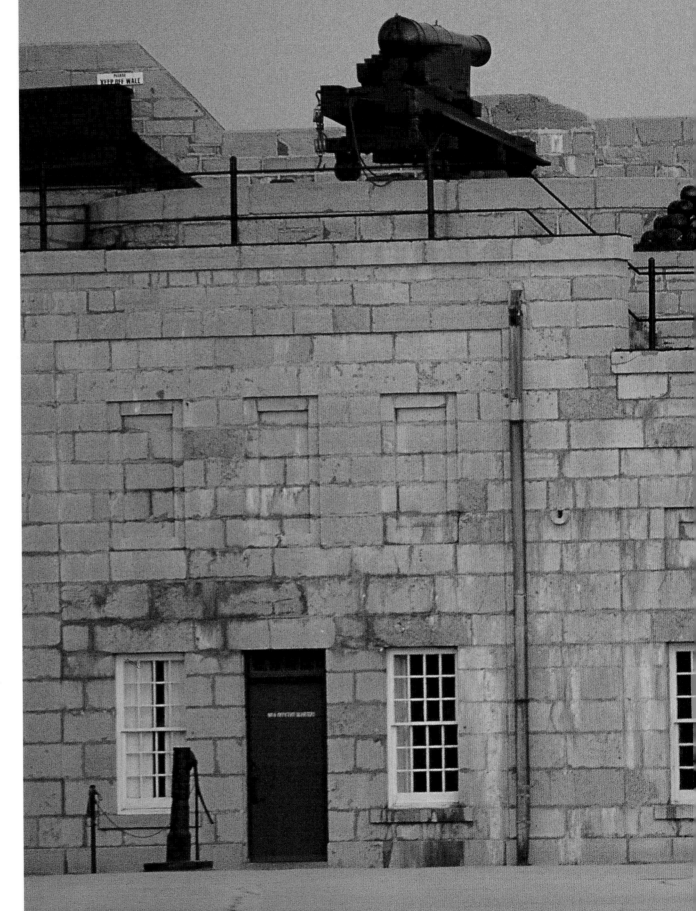

Kingston's Fort Henry was completed in 1837. It was designed to help the British defend trade routes along the newly built Rideau Canal, the St. Lawrence River, and Lake Ontario.

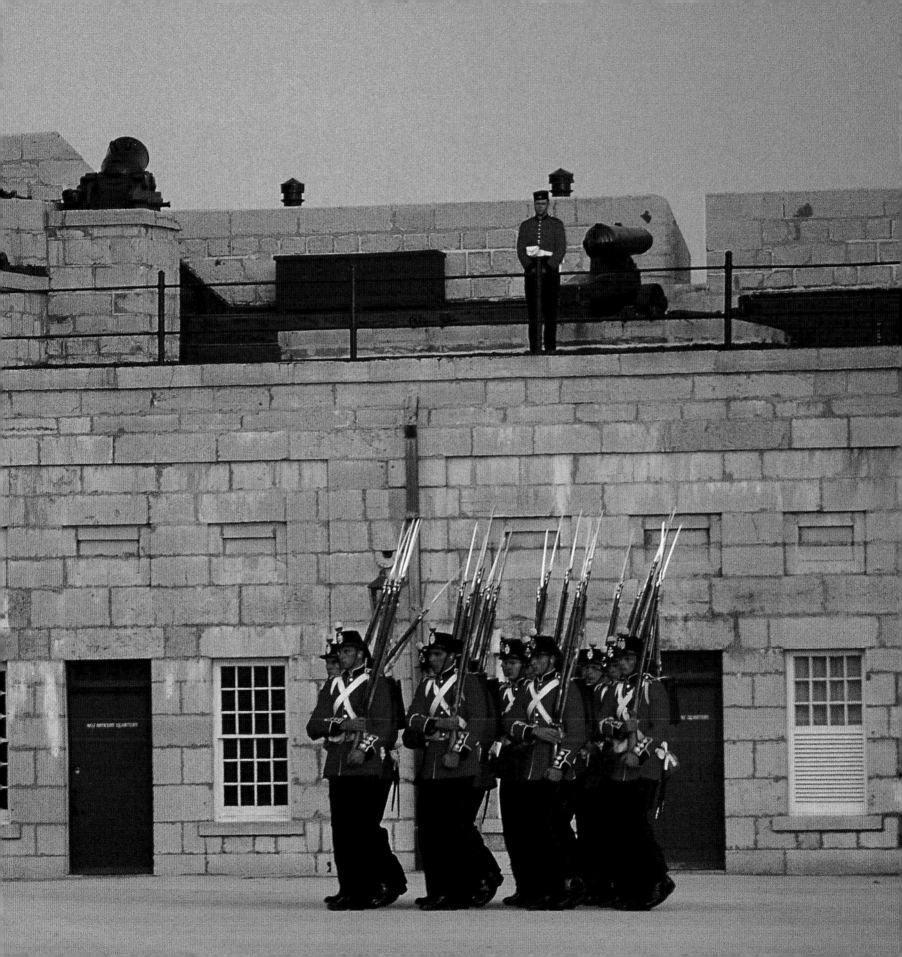

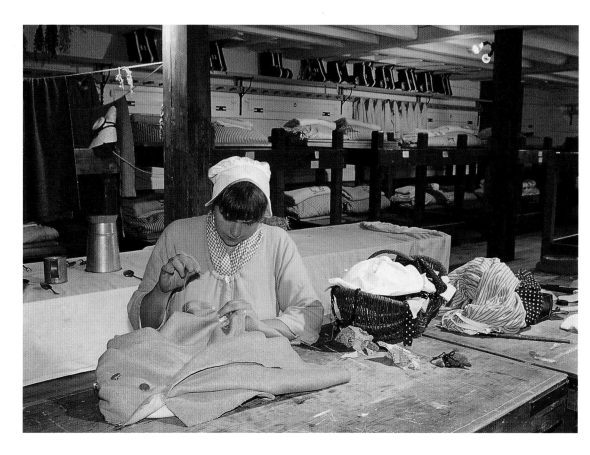

A British base during the War of 1812, Fort George on the Niagara Peninsula was attacked and destroyed by American forces, then rebuilt by the British. Abandoned after the war, the fort has now been restored as a heritage attraction.

The British originally hoped for more defence posts along the trade routes, but the costs of Fort Henry and the Rideau Canal limited their plans.

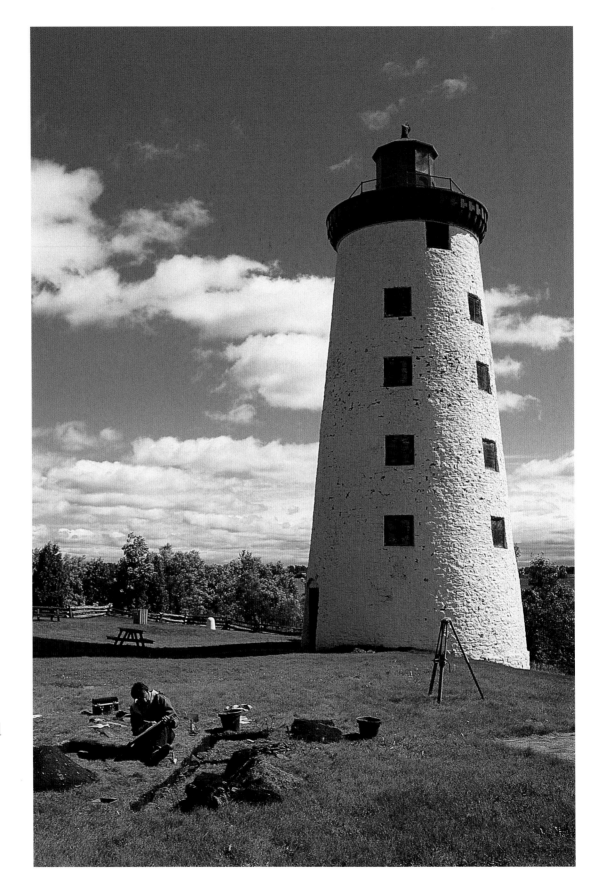

Just east of Prescott, Ontario, archaeologists search for fragments from the 1838 Battle of the Windmill. In the midst of the Patriot War, American troops mistakenly landed here, thinking they were about to attack Fort Wellington. They defended themselves in the windmill for five days before surrendering.

As early as the 1780s, Loyalists arriving in Upper Canada from the south began clearing the land and planting wheat crops. Fifty years later, southern Ontario was a thriving agricultural region.

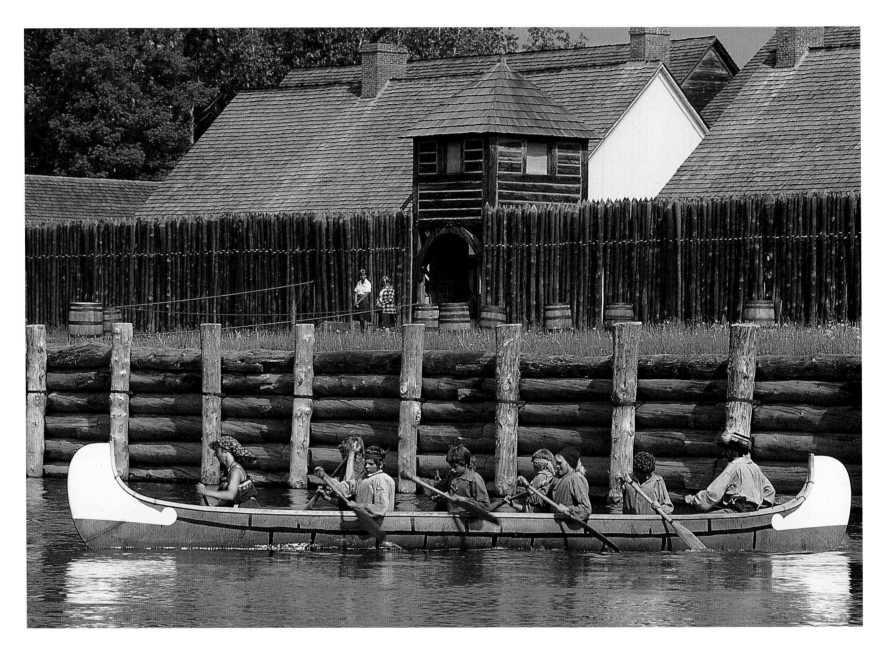

Singing traditional paddling songs as they go, actors stage comings and goings at one of Ontario's historic forts, just as the fur-trading voyageurs would have done centuries ago.

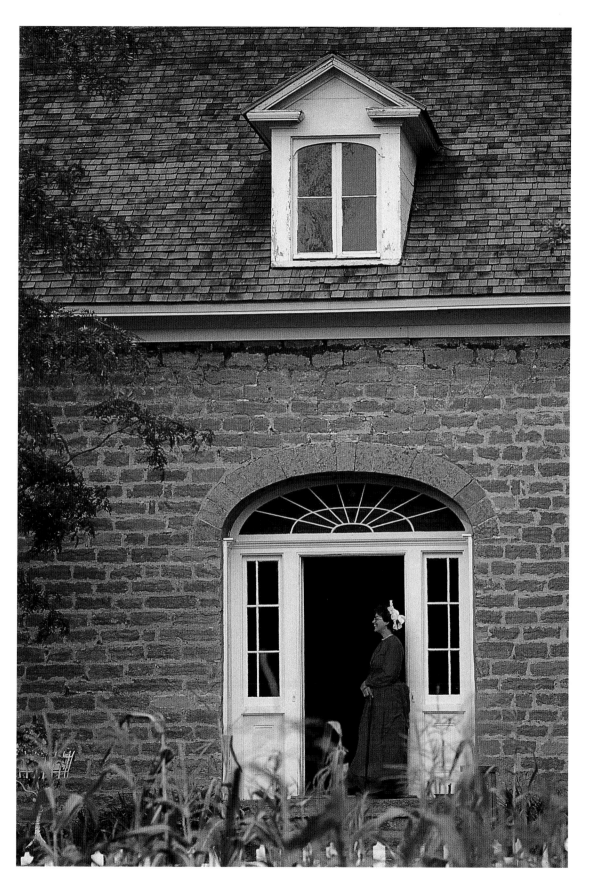

Whether they arrive in spring for the planting or in fall for the annual fair, sightseers at Ontario's Upper Canada Village will find themselves partaking in nineteenth-century rural life.

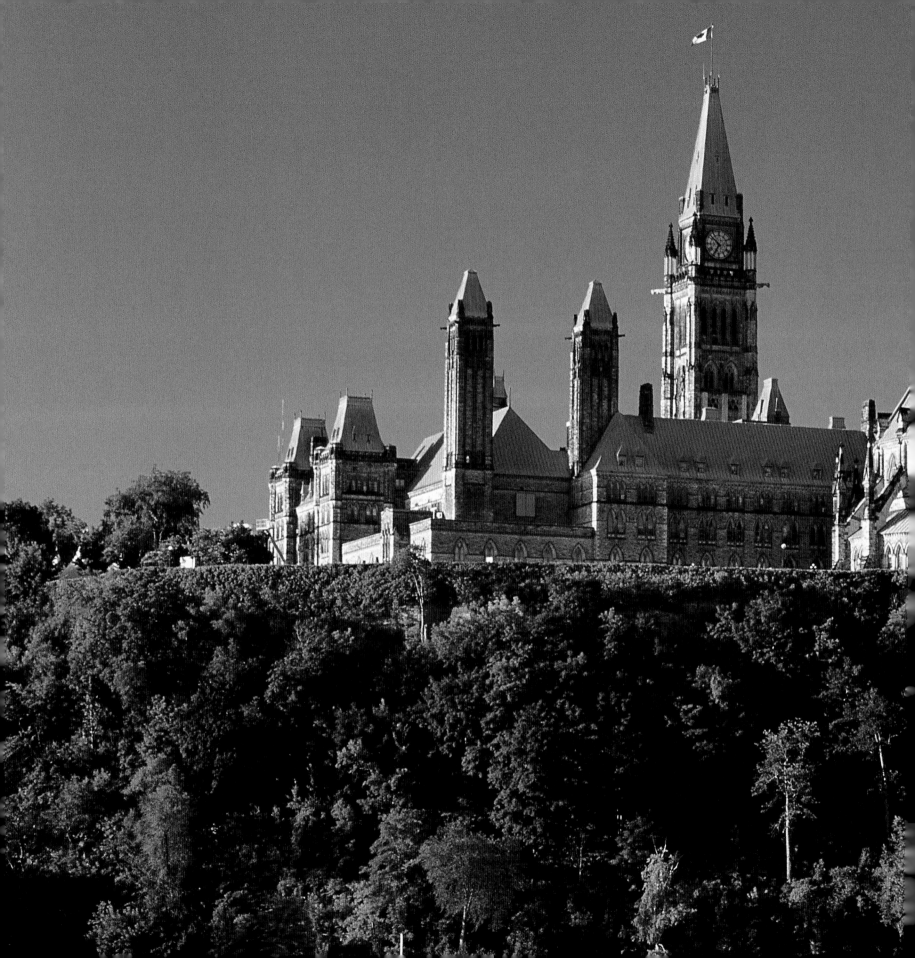

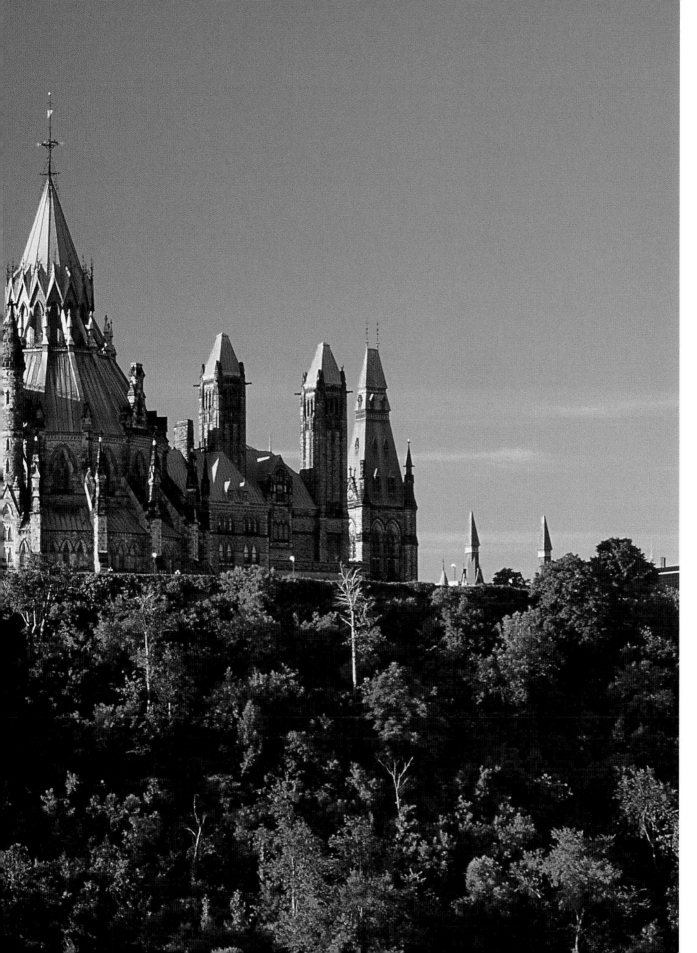

When Thomas Fuller and Chilion Jones designed Ottawa's Parliament Buildings in 1859, the Gothic Revival–style arches were lined with eye-catching red sandstone. When the structure was rebuilt after a fire in 1916, architects followed a similar but less colourful style.

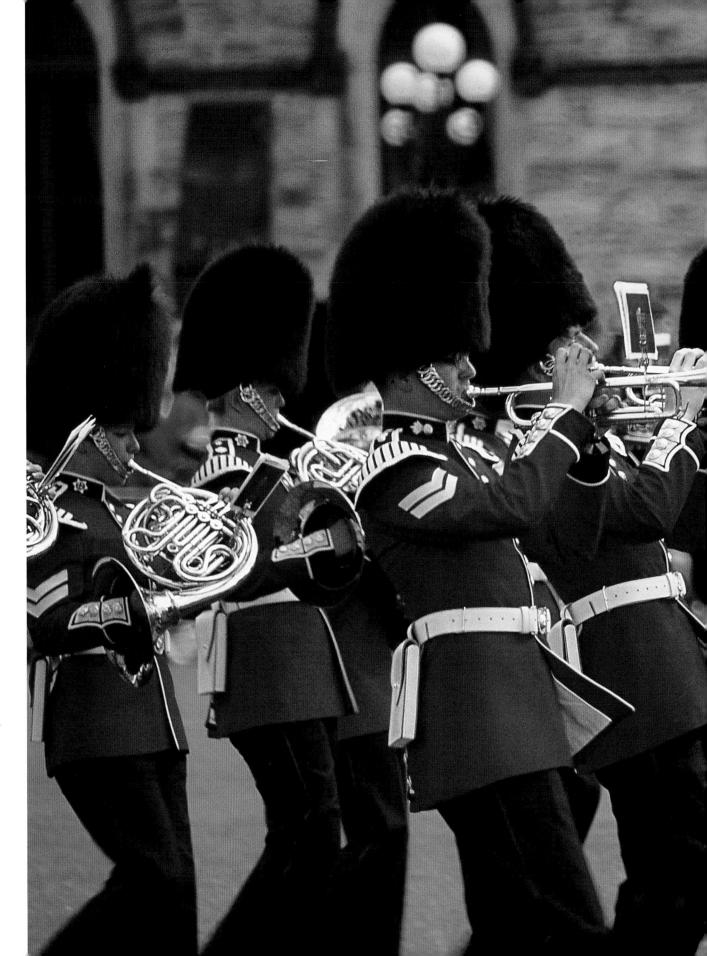

The Changing of the
Guard is a time-
honoured ceremony
on Parliament Hill.
The parade begins at
9:30 each morning at
the Canadian War
Museum, and the
guards exchange
posts on the hill a
half hour later.

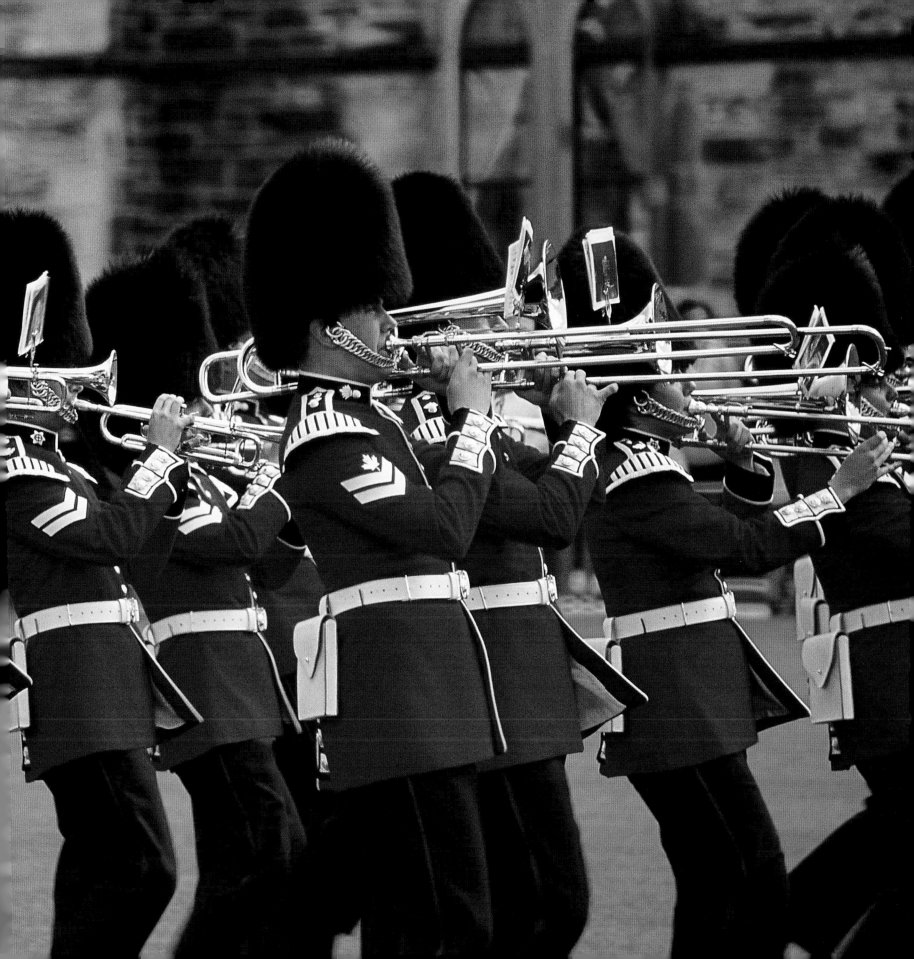

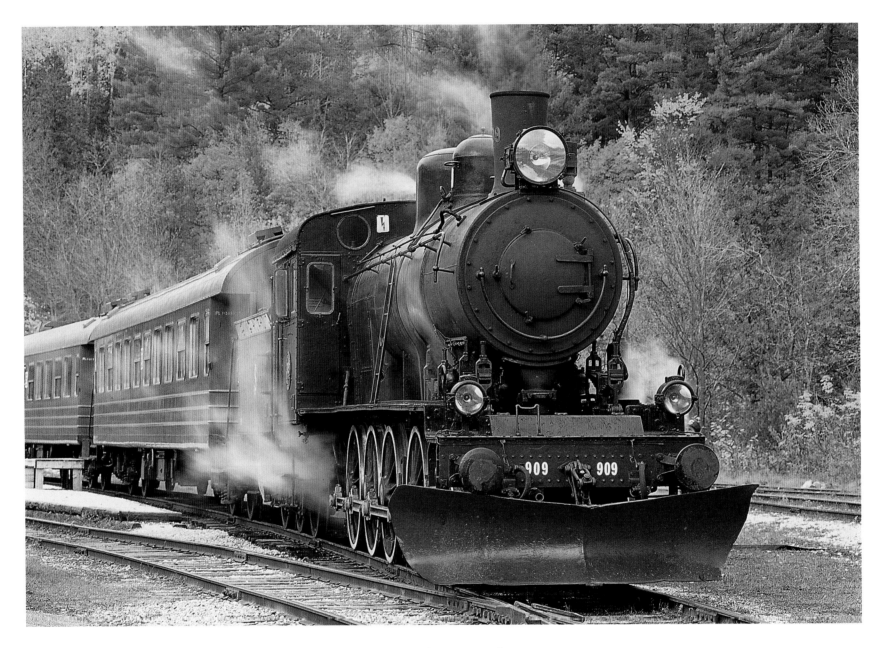

An original steam engine, built in Sweden in 1907 and imported in 1992, pulls sightseers on a 58-kilometre (36-mile) circuit between Hull, Quebec, and Wakefield, Ontario.

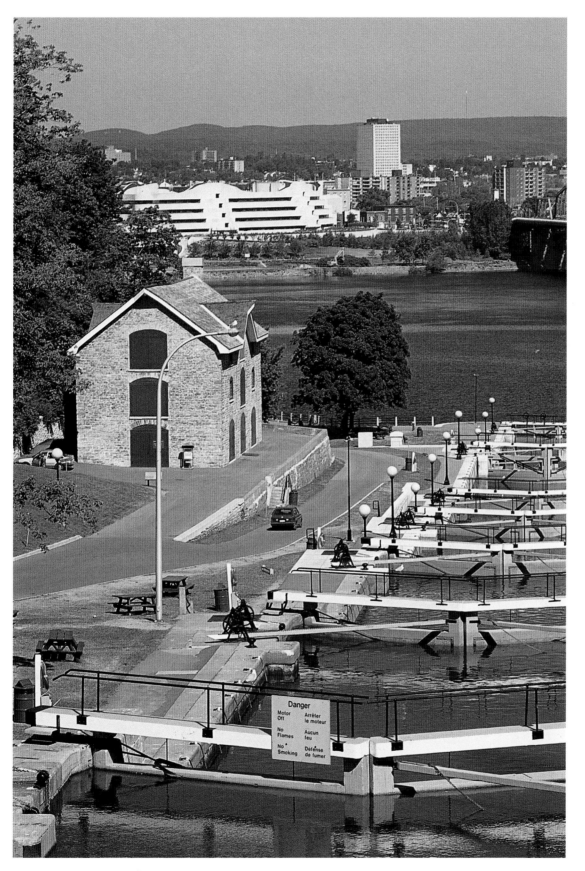

More than 200 kilometres (125 miles) long, with 45 locks, the Rideau Canal winds through lakes, rivers, and artificial channels from Kingston to Ottawa. Though it was built to provide a safe channel for supplies in case the St. Lawrence waterway was threatened, the canal was never used in wartime.

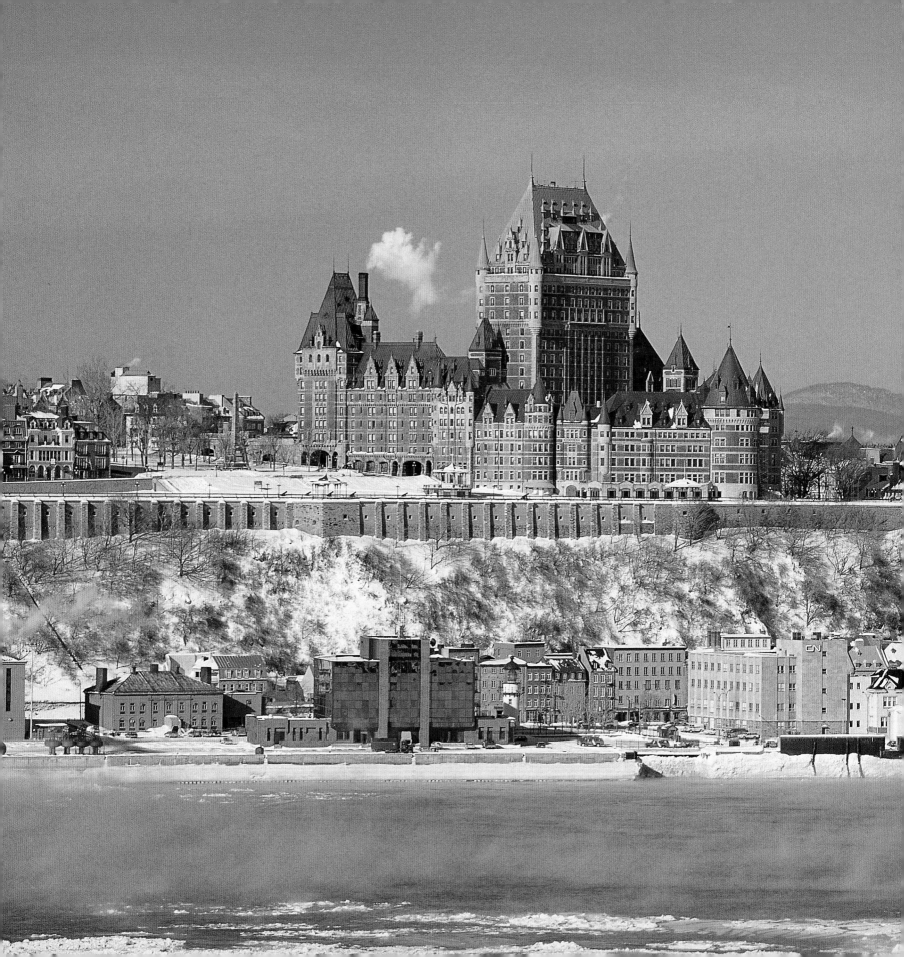

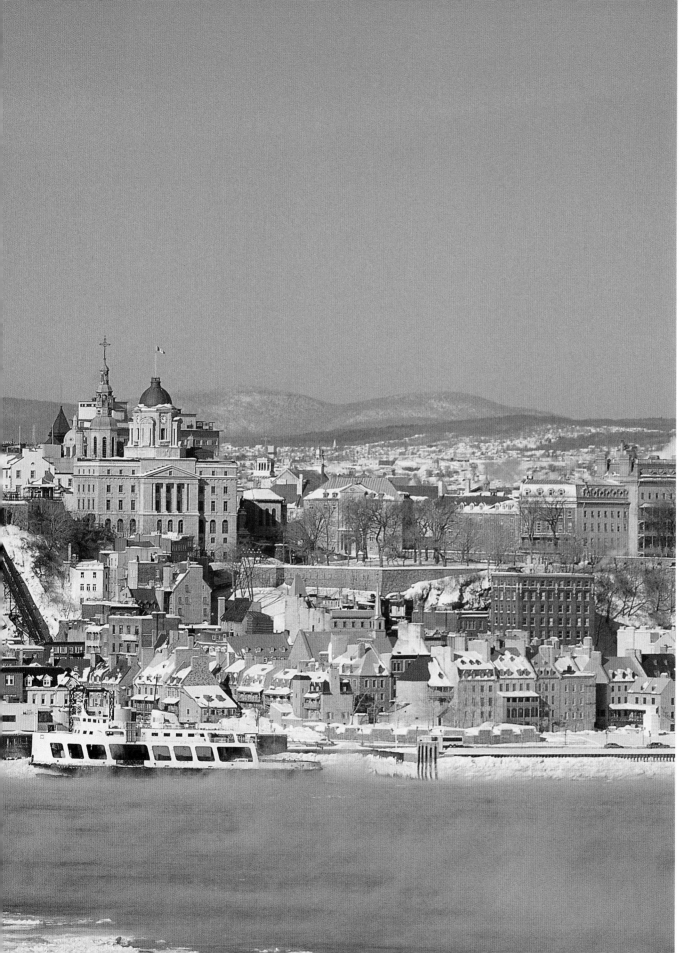

Château Frontenac towers above Quebec City's winding, narrow streets and stone buildings. The hotel itself is more than a century old, built in 1892 by the Canadian Pacific Railway.

The only remaining fortified city north of Mexico, Quebec City was founded by explorer Samuel de Champlain in 1608. Its position above the St. Lawrence made it a vital commercial centre as well as a strategic post.

FACING PAGE—
La Pulperie de Chicoutimi, a historic pulp and paper mill, is a favourite stopping place for visitors to Quebec. The building in the foreground was completed in 1912, and partly destroyed by a massive flood in 1996. The building in the background was built in 1903.

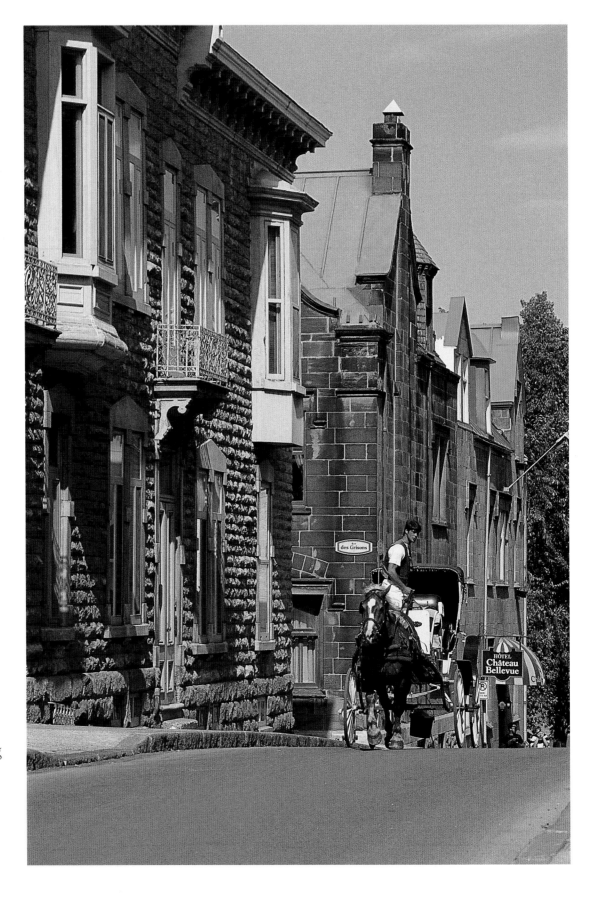

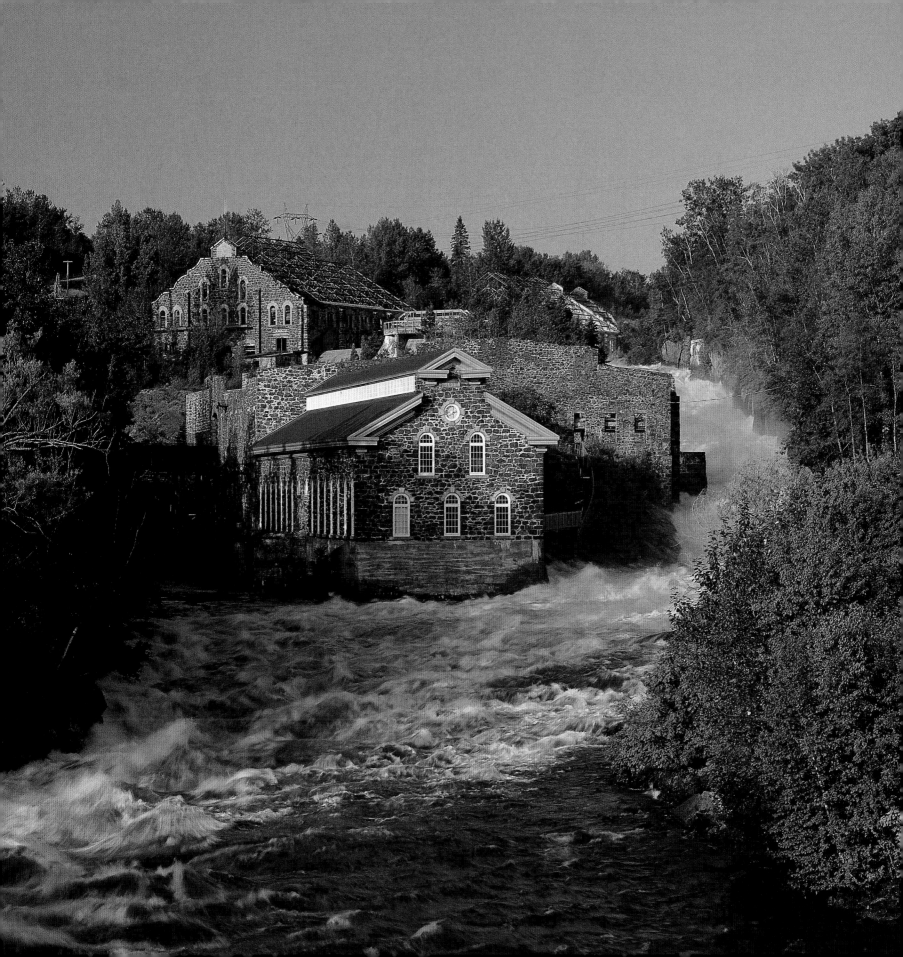

There were once 115 covered bridges in Quebec, built to keep snow and ice off the slippery wooden decks. Only a few remain, most in the province's Eastern Townships.

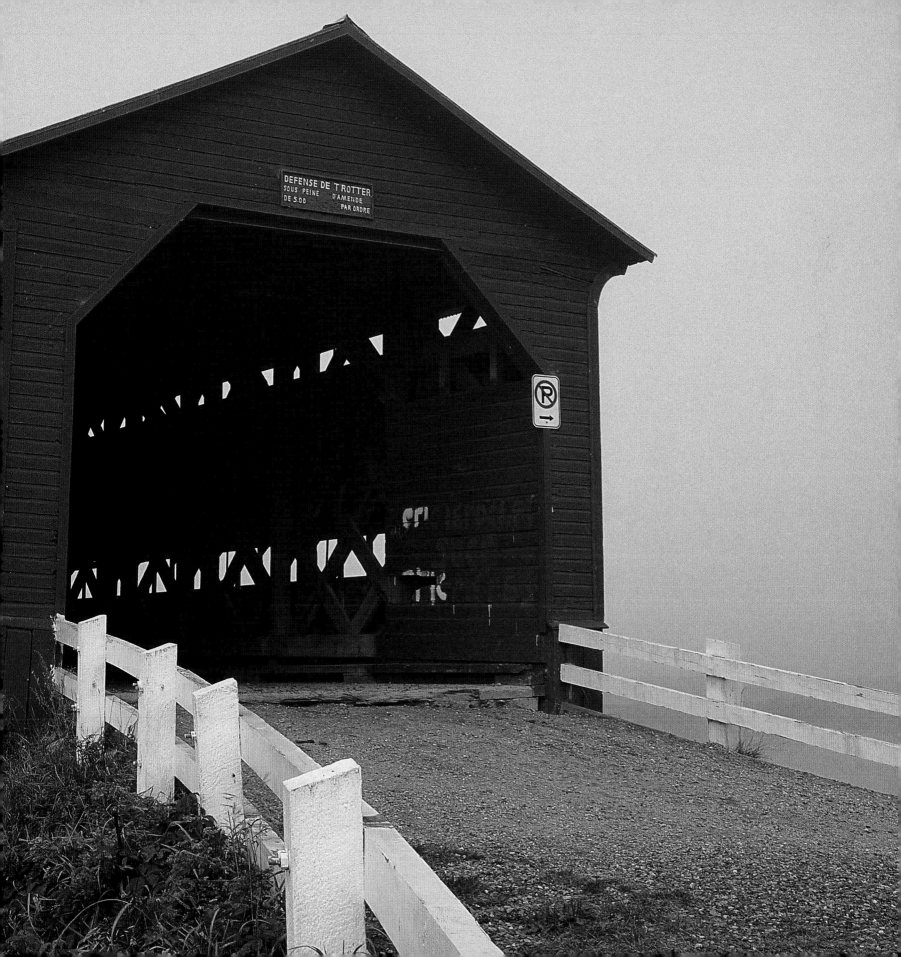

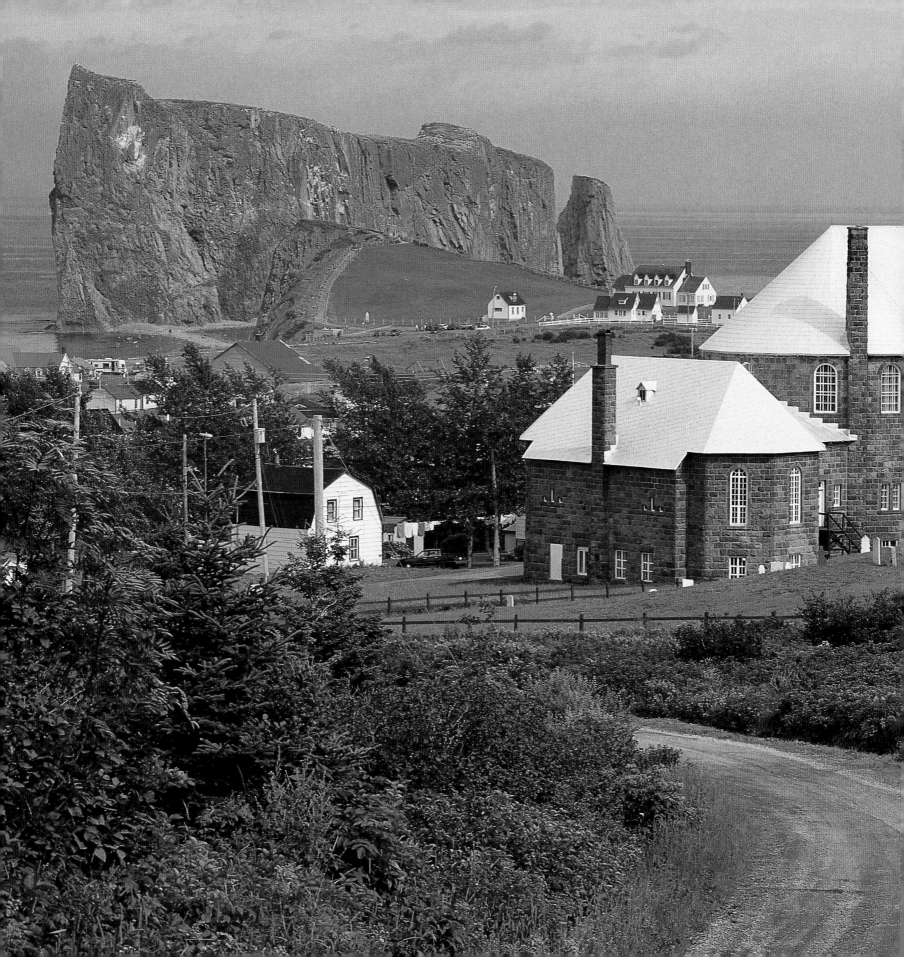

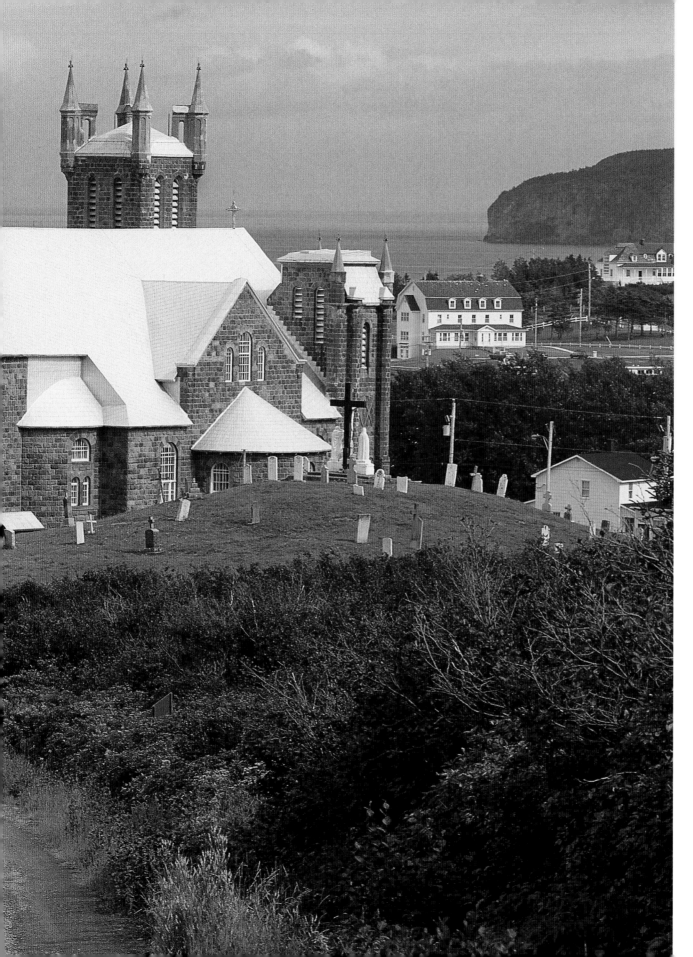

Within Forillon
National Park on
Quebec's Gaspé
Peninsula, the
Grande-Grave
National Historic
Site preserves the
culture and heritage
of the fishing families
who once lived
clustered around
these shores, plying
the waters for cod.

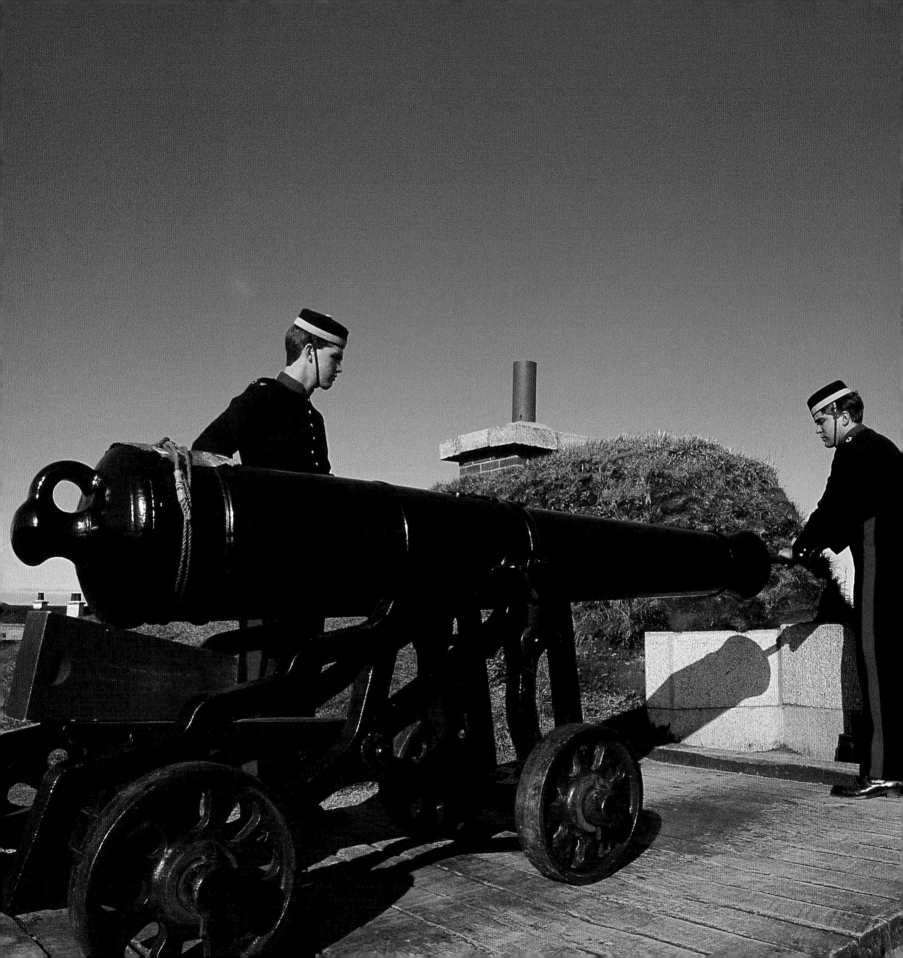

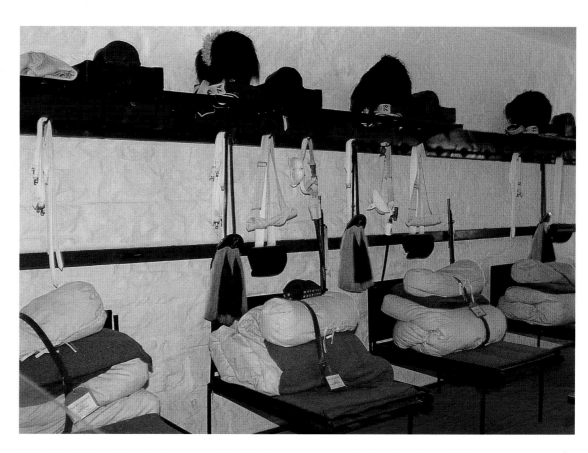

The Halifax Citadel housed British troops until the early 1900s; it was later home to Canadian forces during both World Wars.

Starting in 1749, the British built a series of forts to defend Halifax Harbour. Halifax Citadel, now protected as a national historic site, took 28 years to build and was completed in 1856.

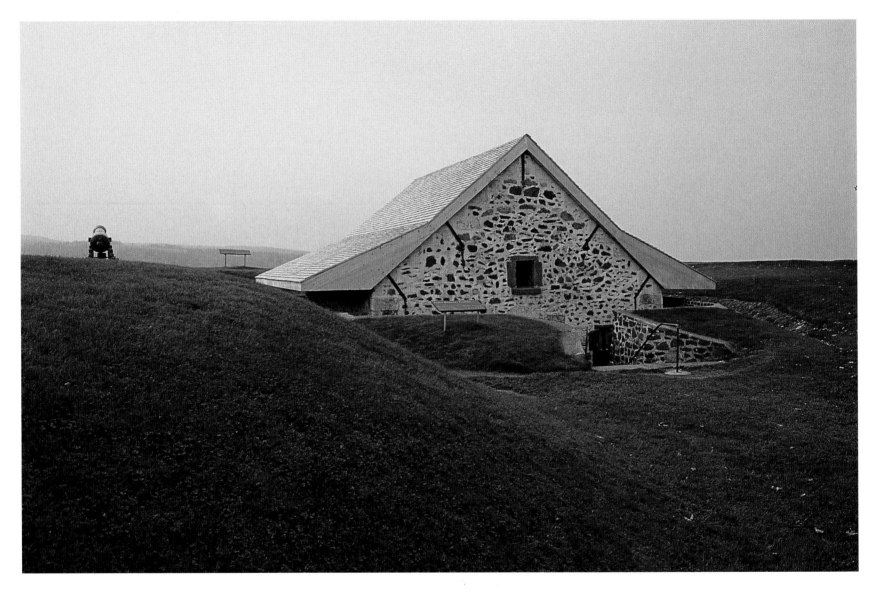

In 1604, disease and starvation decimated a new settlement off the
coast of Nova Scotia. The following summer, Samuel de Champlain
and François Pont-Gravé selected a more welcoming site at Port-Royal.

Despite fertile soil and friendly relations with the local First Nations
people, the settlement at Port-Royal was constantly threatened by
lack of funding from Britain and attacks by American colonists. It
was eventually destroyed, to be rebuilt as a historic site in 1940.

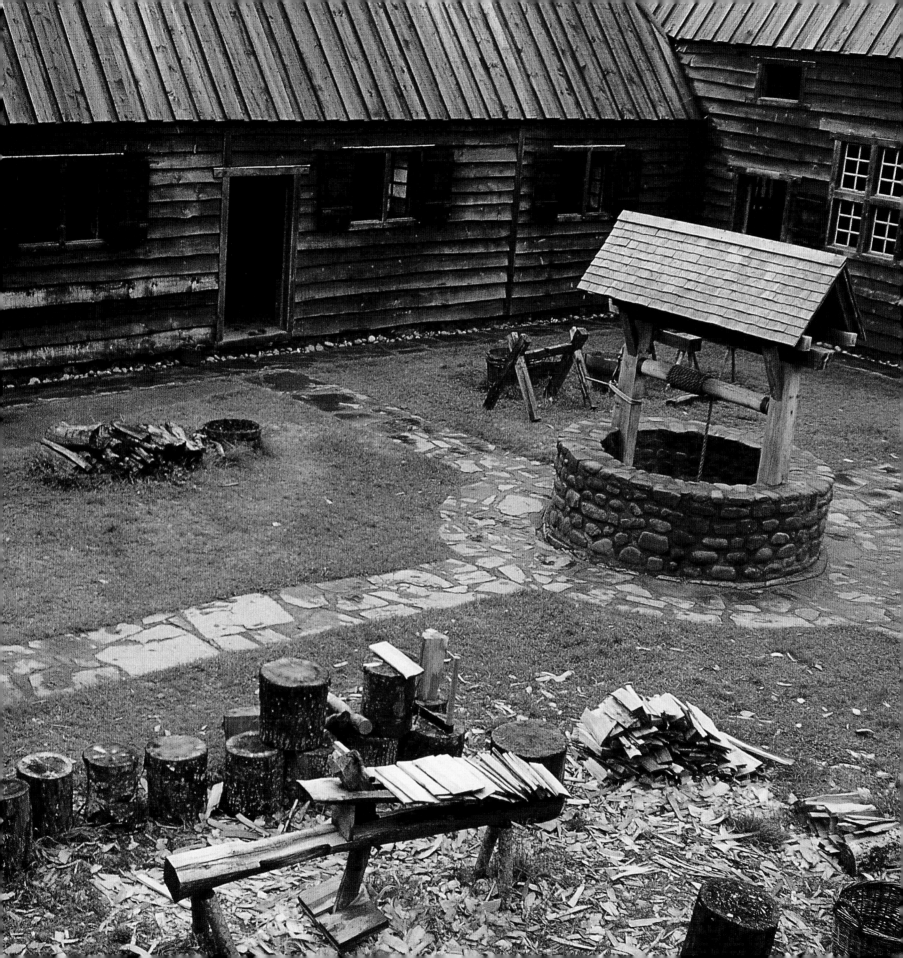

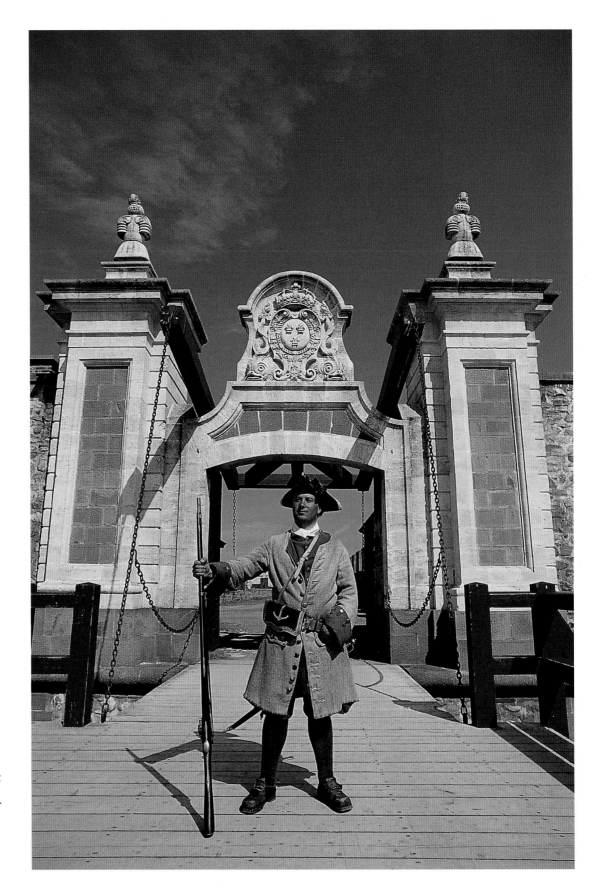

At the Fortress of Louisbourg in Nova Scotia, a hundred costumed staff stand ready at the cannons, guard the gates, and reenact eighteenth-century daily life inside the massive French stronghold.

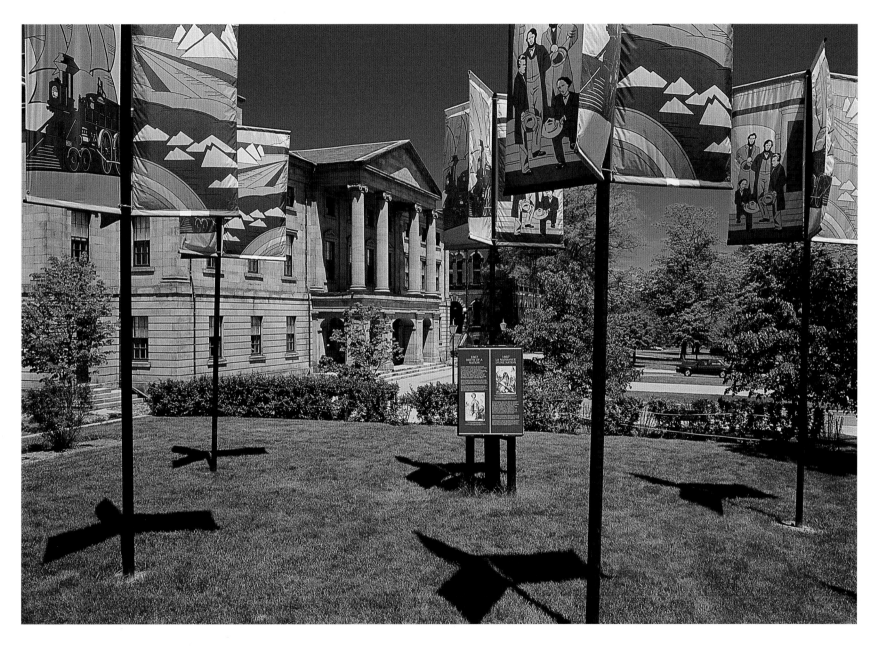

In September 1864, delegates from Prince Edward Island, New Brunswick, Nova Scotia, and Canada—all colonies of Britain at the time—met at Province House in Charlottetown, Prince Edward Island, to discuss confederation. The national historic site here today honours the birth of a new nation.

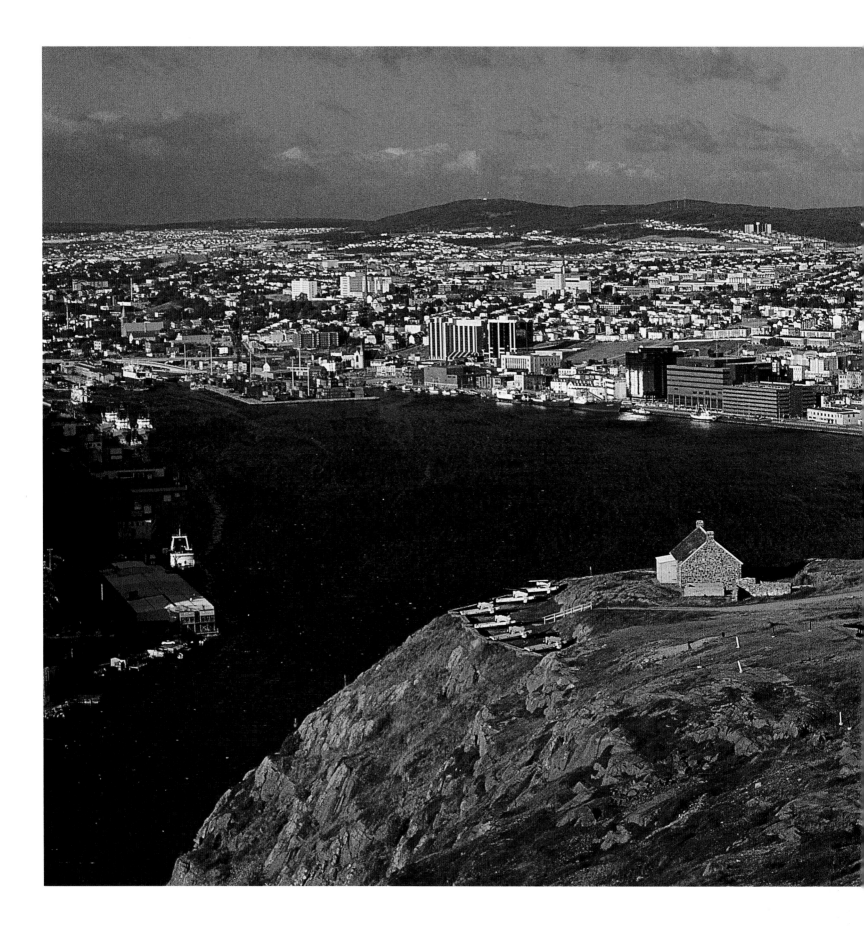

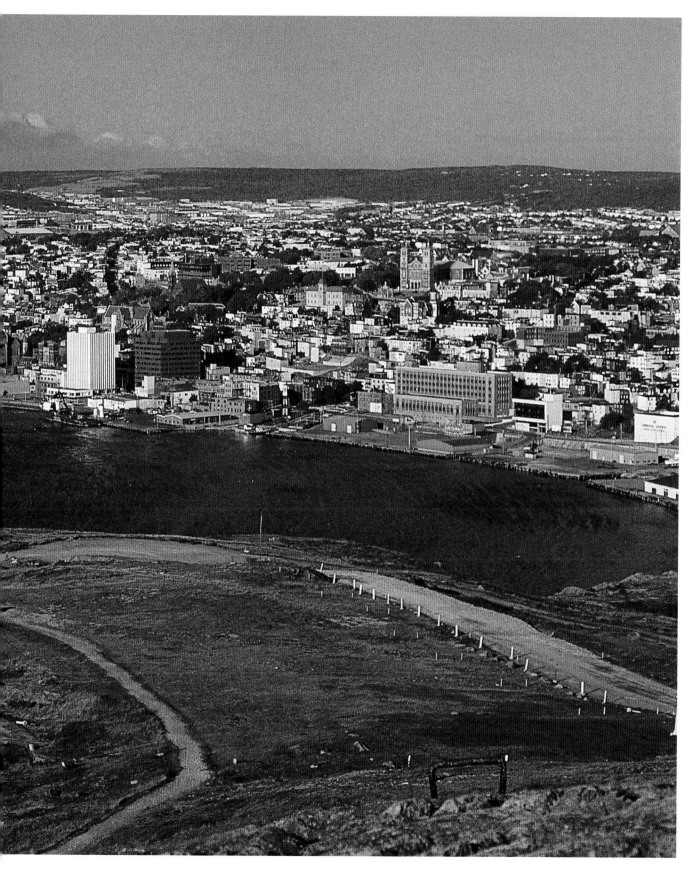

To capture this spectacular image of the St. John's harbour, the photographer has climbed Signal Hill, once the site of the harbour's defence system. In 1901, inventor Guglielmo Marconi received the first trans-Atlantic wireless signal at this point.

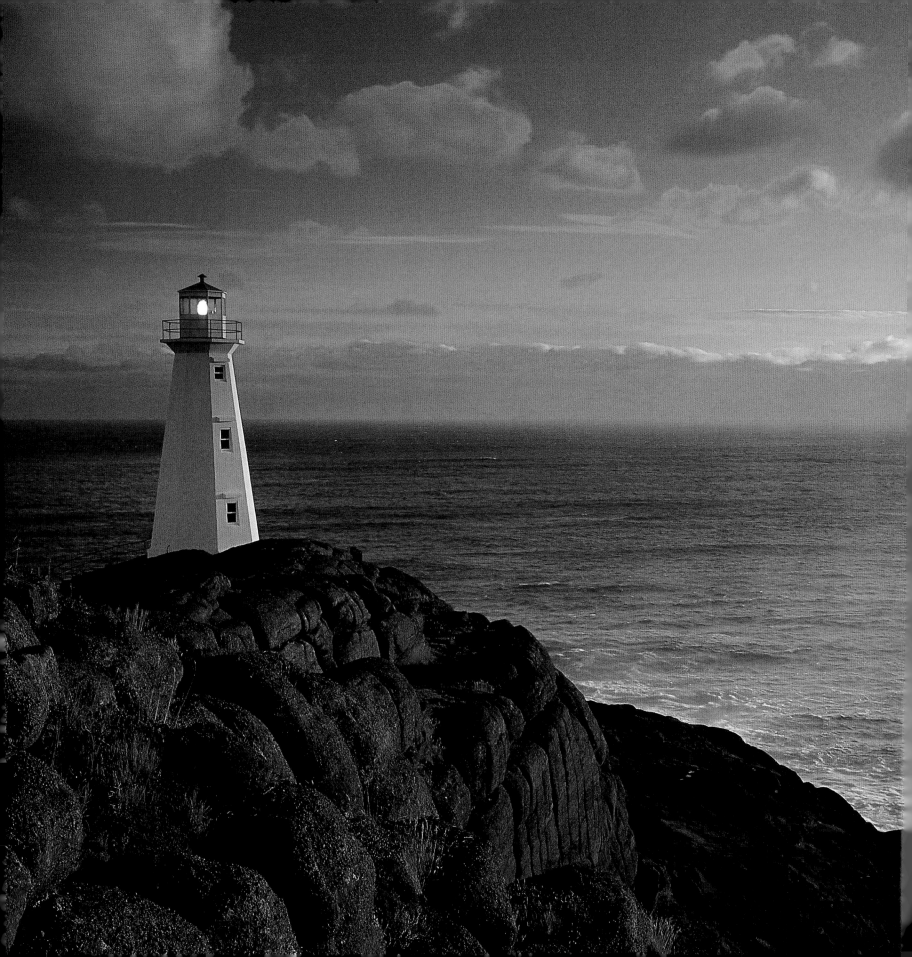

The Cape Spear light has been guiding ships into St. John's harbour since 1839. Now the oldest surviving lighthouse in Newfoundland, it has been restored to its nineteenth-century state.

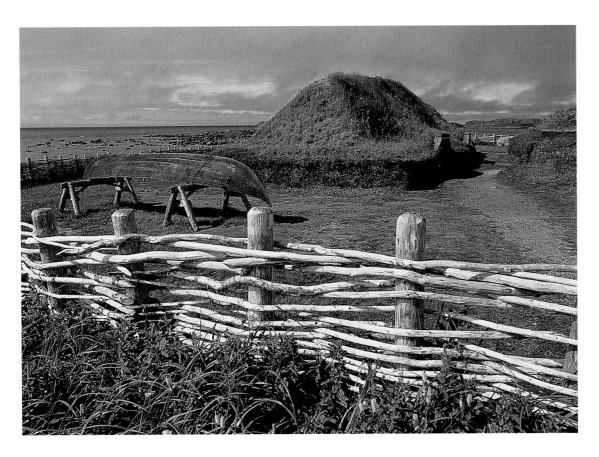

Long before Champlain and Cartier arrived on Canadian shores, Vikings founded a settlement at what is now L'Anse aux Meadows National Historic Site in Newfoundland. The site's rich archaeological finds earned it a place as a UNESCO World Heritage Site in 1978.

The largest wooden-hull, bucket-line dredge on the continent, Dredge No. 4 was built for the Canadian Klondike Mining Company near Dawson City in 1912. At times, it produced up to 22 kilograms (800 ounces) of gold per day.

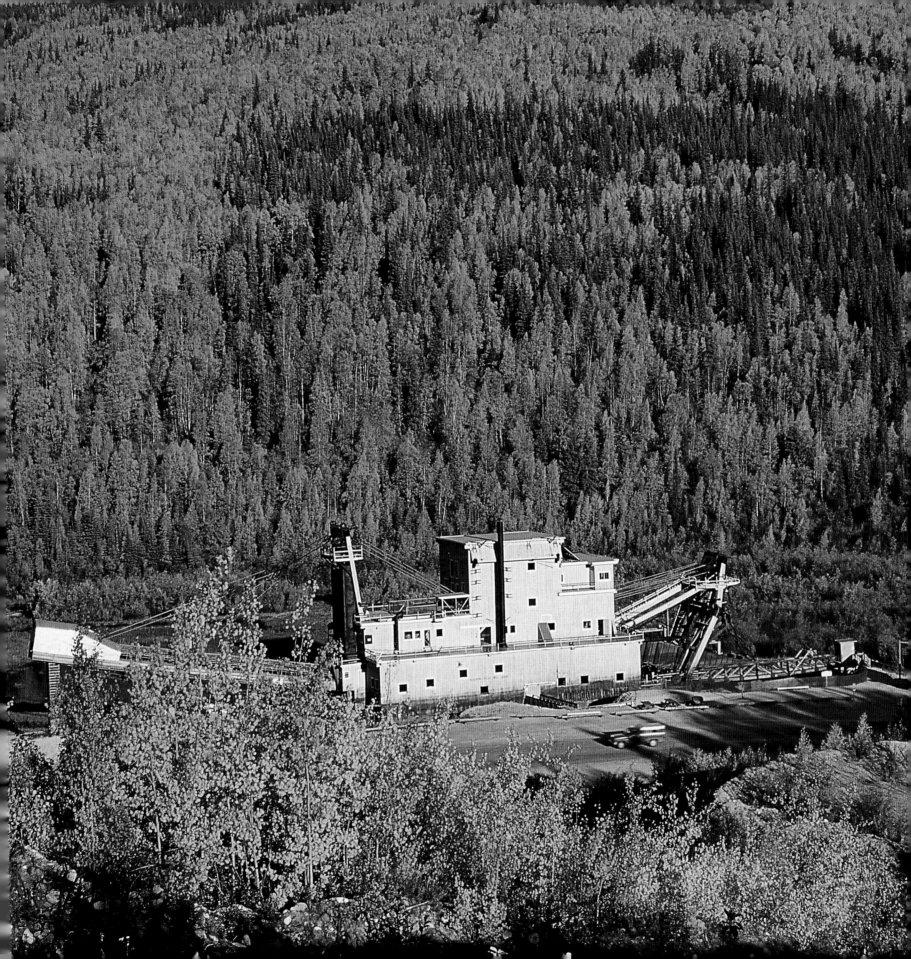

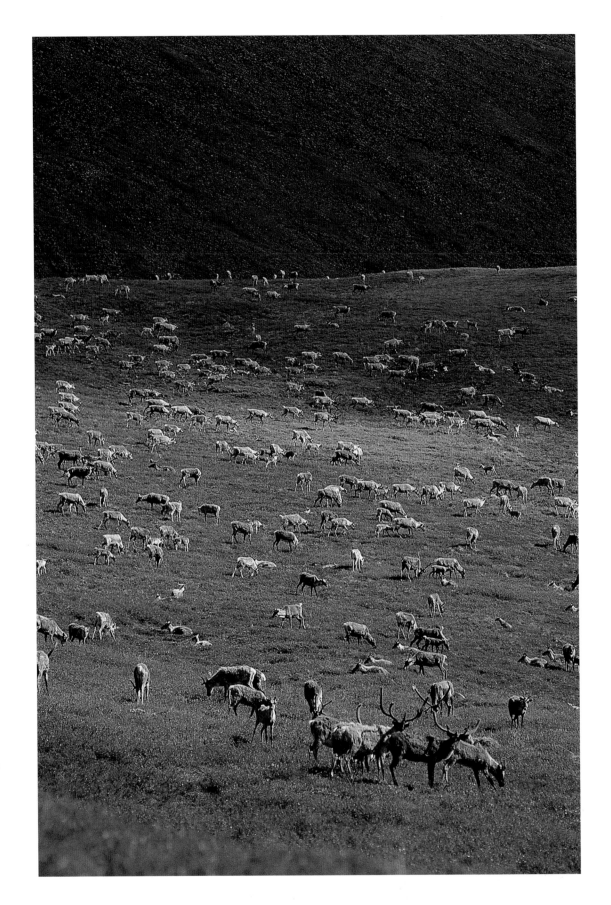

Providing food, clothing, and shelter for First Nations people for thousands of years, the Porcupine caribou herd follows an annual migration route from Alaska, where they calve, through the Yukon to the North-west Territories.

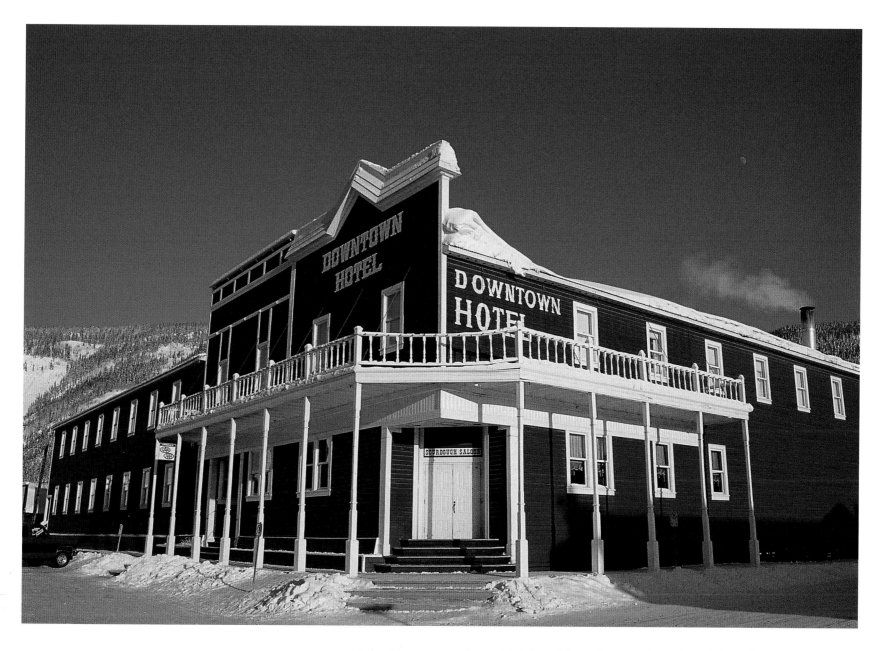

With the news of an 1896 gold strike in the Klondike, thousands of fortune seekers swarmed north. Dawson City grew to 30,000 people, making it the largest city west of Winnipeg.

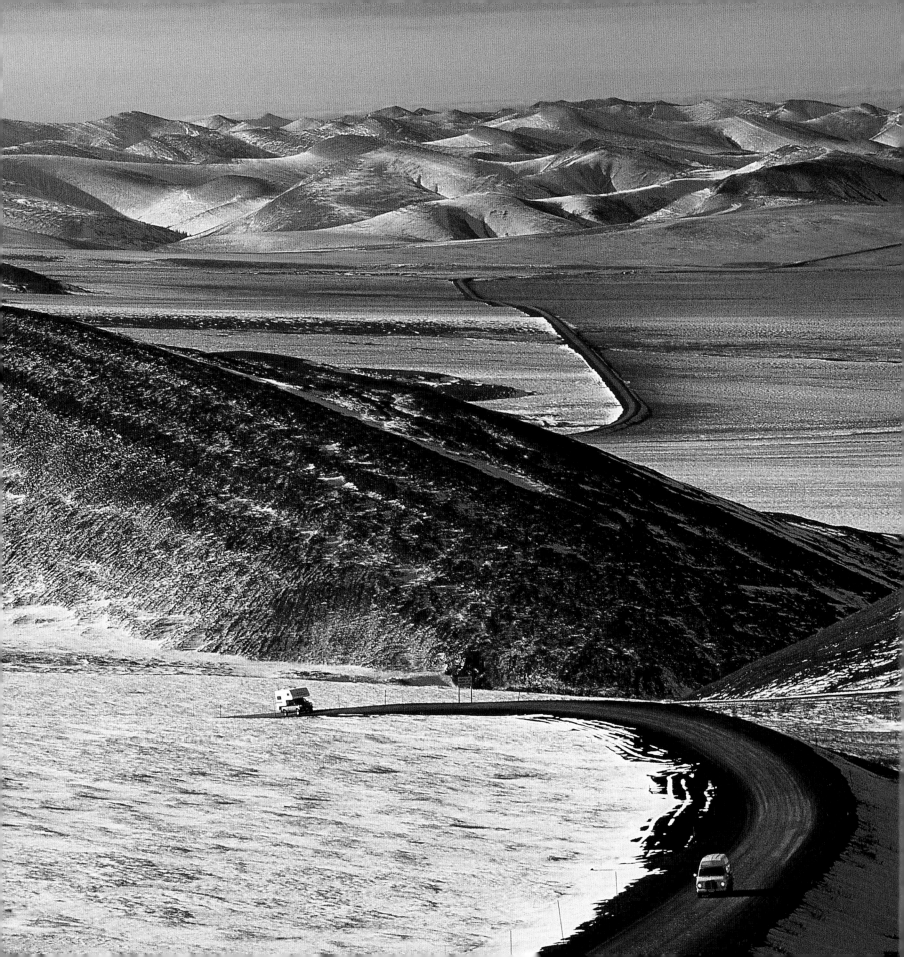

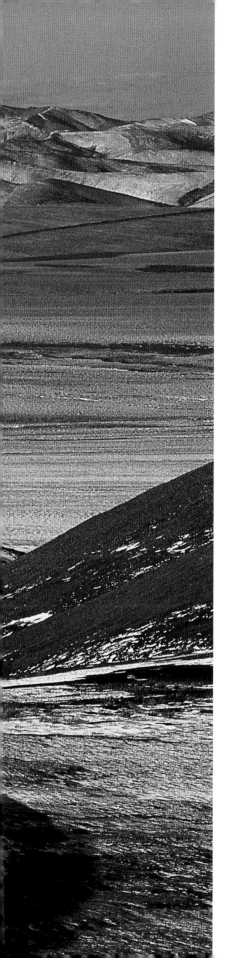

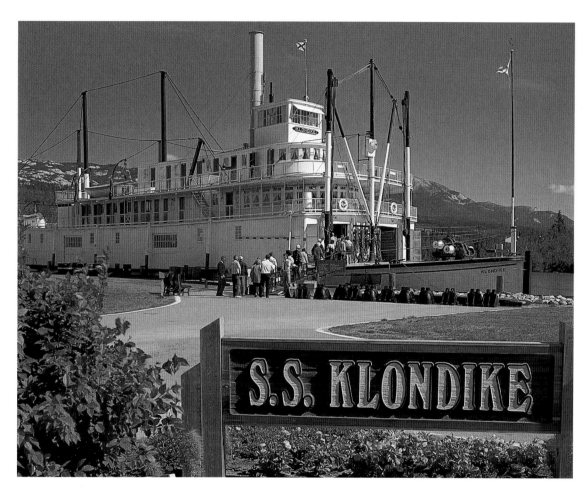

When the S.S. *Klondike II* was launched in 1937, it was the last river boat to ply the waters of the Klondike, carrying supplies and adventure seekers into the north. It is now the Yukon's only river boat open to the public.

The Dempster Highway between Dawson City, Yukon, and the Northwest Territories took more than two decades to build in the mid-1900s. The highway is the only one in Canada to cross the Arctic Circle.

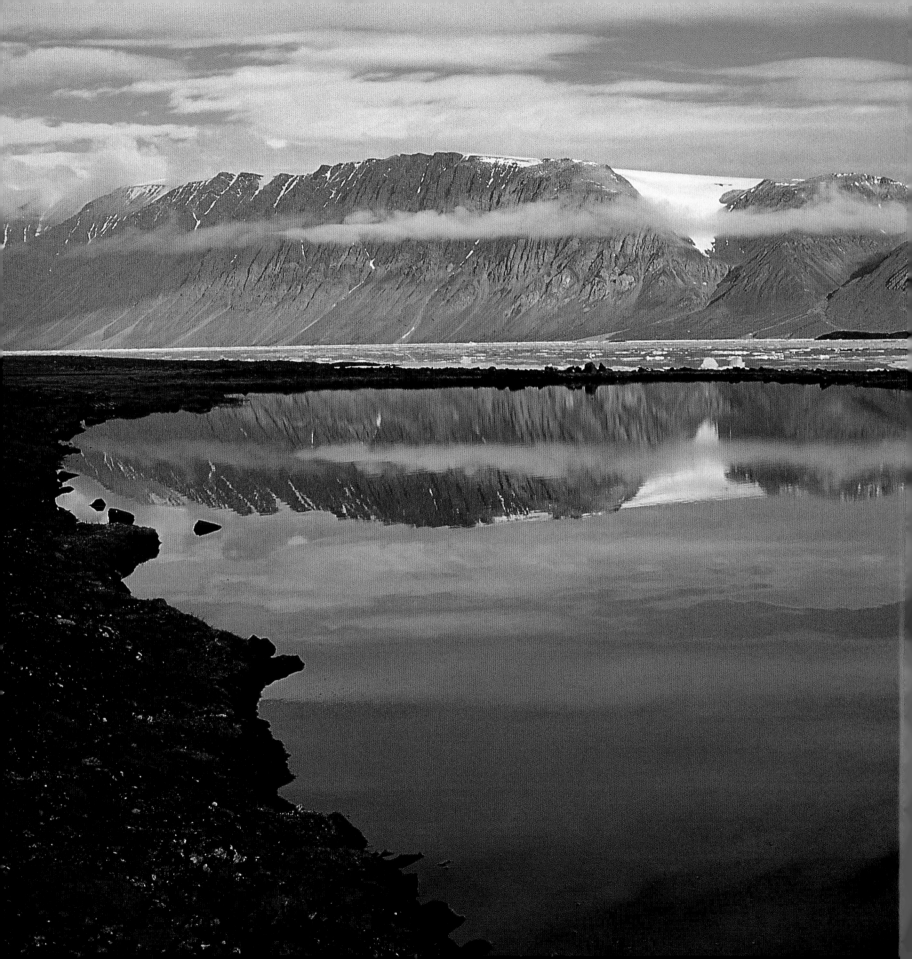

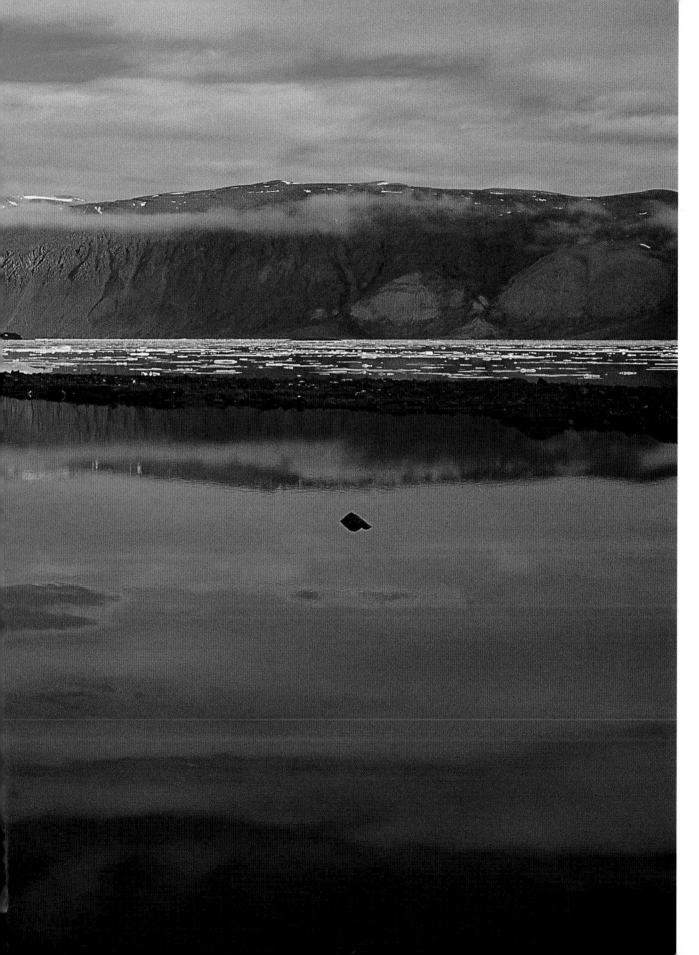

Partly managed by the region's Inuit people, Quttinirpaaq, or Ellesmere Island National Park, protects some of Nunavut's natural diversity as well as outposts of northern exploration. Captain Stephenson, Sir George Nares, Adolphus Greely, and Robert Peary all used the island as a base.

Photo Credits